D1270858

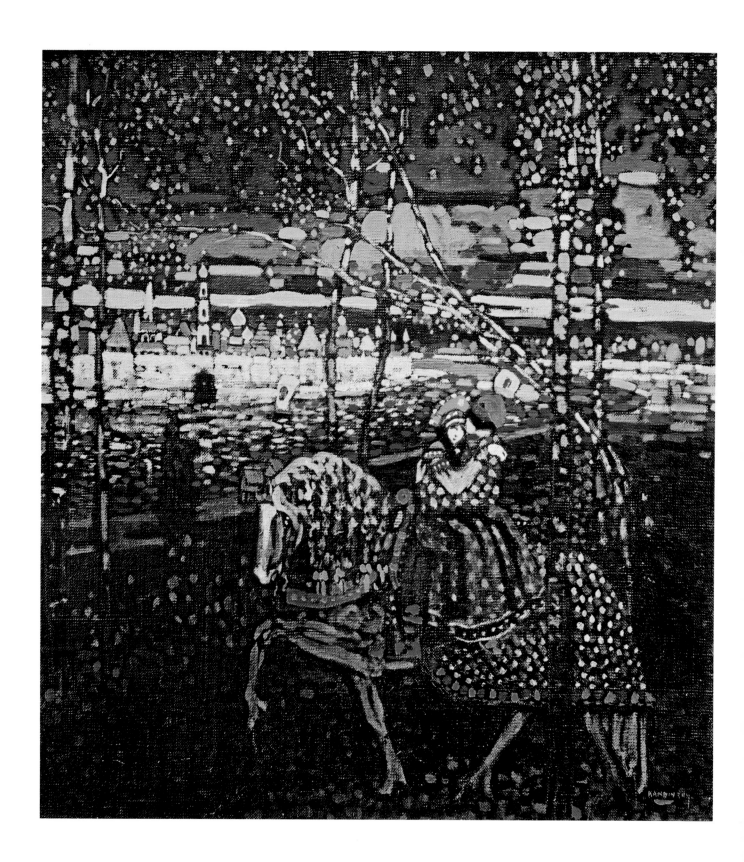

LOVERS
IN ART

Selected by **Franziska Stegmann**
With a foreword by **Bettina Schümann**

PRESTEL
MUNICH · LONDON · NEW YORK

The Kaleidoscope of **Love**

—— Bettina Schümann

What is Love?

Each and every one of us encounters love personally. What we make of it in our lives is determined by our understanding, our needs and circumstances. So no wonder that virtually every story we hear tells of love in some form or other. And no wonder that we are also so anxious to hear about it.

 We experience longing. The overwhelming feeling of being in love. Our feelings are independent and free! Passion is what counts. Dreams, eroticism and romance. Drives, desire and sex. Beauty and sensuousness, helplessness and power. Seeing oneself mirrored in the other person, losing oneself in him or her. Fear. Hatred. Clichés concerning our roles in life. Woman, man, child. Anger, disappointment, deceit, faithfulness. Affinity, loyalty, trust. A feeling of being pampered. Contempt and respect. Feelings versus norms. Spiritual kinship. Empathy, understanding, security.

Does the path of love always have to follow the same pattern? "Falling in love, betrothed, married, divorced," is one saying. "Falling in love, betrothed, married – and lonely" could be a variation on the theme. And yet – couples "take the plunge" time and again: "We'll be different from the others! We'll succeed!" – Yes, what's it really about?

 Each of us cherishes the hope that we can preserve the feeling of being in love, the openness and excitement in the face of the inexorable ravages of everyday life. But the numbers of singles and the number of the divorced are both on the increase. And so are the numbers of patchwork families as they make a conscious decision to try to influence the course of their lives and summons the courage for a fresh start.

Life narrates an infinite number of love stories in every possible permutation and combination – as it has done since the birth of the human race. And apart from the true stories, there are also the imagined ones. Stories of princes and peasants, queens and gods. Stories that tell it as it is, and those that carry us off into cloud-cuckoo land. And some attempt, through the act of telling the story, to actually understand something of the nature of love.

The loves of the gods

Mythology is full of stories of love and longing. The tale is told, for example, of the love of the winged god Cupid and a beautiful mortal, Psyche → pages 42, 43, 82–83. Cupid was the son of Venus, the goddess of love, and she – long before Cupid and Psyche became lovers – was mad with envy at the beauty of her lovely rival, who was, what was more, a mere mortal! It was no longer *her* beauty, but that of Psyche, that was the object of universal admiration! To put an end to the intolerable situation, Venus summoned her son and ordered him: "See to it that Psyche falls in love with the least worthy of all men," adding: "He must be a true monster!" Cupid set off to obey her instructions.

As soon as he set eyes on Psyche, however, he fell in love with her beauty and had her carried off by a gentle wind to a faraway place. There Psyche lived as in a dream. Every night she received an unknown visitor under cover of darkness; every night, a feast of sensual pleasure took place. Her mysterious lover made only one condition: she must never attempt to find out who he was, nor should she ever desire to set eyes on him!

But then she began to have doubts. What if every night a hideous monster was creeping into her bed? What if he devoured her?

So one night, Psyche plucked up her courage. Waiting until her lover was asleep, she quietly slipped out of bed, lit the oil lamp with trembling fingers – and found herself gazing at the handsome figure of the sleeping god. What a surprise! Involuntarily, she gave a start. A drop of hot oil fell onto Cupid's skin. He woke and flew away.

Venus was filled with wrath. She implored Jupiter, the ruler of the gods, to punish her son. Cupid also appealed to Jupiter. The latter chose the direct way to restore order: he made Psyche immortal and thereby smoothed the way for the lovers to marry. "Love" and "Soul" finally celebrated a riotous feast among the gods on Olympus – including Venus.

Venus herself had fallen passionately in love with the handsome Adonis → page 80. Intrepid, young and wild, he loved above all else the adventure and risk of hunting. Venus herself accompanied him through the forests, patiently chasing rabbits and deer with him, baulking at neither thorns nor sharp-edged rocks in order to be with him. But she also realised the dangers and warned her lover urgently about bears, wolves, wild boar and lions.

Adonis ignored the warnings. "Do not go today!" Venus begged him – in vain. She sadly climbed into her chariot drawn by swans and flew away. Adonis, however, went out hunting and soon tracked down a wild boar. He valiantly threw his spear – and hit the creature without killing it. The wounded animal charged at the huntsman and pierced him in the abdomen with its mighty tusks. Could it have been Mars, the jealous god of war?

High up in the sky, Venus heard the death cry of Adonis. She turned back at once and hastened to mourn beside her lover. When she tenderly poured nectar onto his blood, a lovely red flower sprouted from each sweet drop. Since then the red anemone flowers anew ever year.

And Jupiter? As everyone knows, he was a sly old dog. He was always finding new ways of seducing his current favourite. As a golden shower (→ with Danaë), a swan (→ with Leda) or a bull (with Europa). And his adventure with Io inspired the Renaissance artist Correggio to create a picture that was regarded as the most erotic work of its time → page 69. Io was a virgin and a priestess – dedicated, what is more, to Jupiter's wife Juno. The fact that she attempted to avoid his advances did not discourage Jupiter – on the contrary, it merely roused his desire and determination. This time he changed himself into a large black cloud. Without warning he enveloped Io and nestled softly and cajolingly up to her and into her, while she had completely lost all sense of orientation.

Juno, of course, got wind of events. Jupiter therefore turned his beloved into a cow for her own protection, since cows were sacred to Juno. He then presented the creature to his jealous wife. Only in Egypt, after various entanglements, did he finally turn Io back into the young woman she had originally been. From that point onwards she was worshipped in that country as the goddess Isis.

Of beasts and men

The tales of Antiquity have provided artists with countless opportunities to depict love, eroticism and sensuality. Artists had no compunction about showing women with animals; there were, for example, endless variations portraying Leda with the "swan" (Jupiter) – the "divine" connotations made such images acceptable.

It is therefore surprising that at an exhibition in Cologne in 1967, the police appeared and covered up the pictures by the Pop Art painter Mel Ramos because they were considered "immoral": the naked women shown posing on the canvas with seal, hippopotamus or kangaroo were hidden from view.

Why were people so incensed? At the exposure of the female body as such? Or at the juxtaposition of human and animal for such "bestial" purposes?

How animal-like are we then really? "Very," insist evolutionary psychologists, referring back to Charles Darwin and to the theory of genetics, "driven to a far greater extent by hidden desires than we previously thought was the case," according to Sigmund Freud and psychoanalysis. So, what are we really like? Or, to put it differently: Who are we?

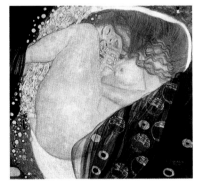

Gustav Klimt
Danaë
c. 1907/08, oil on canvas,
77 × 83 cm,
private collection

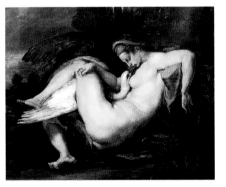

Peter Paul Rubens
Leda and the Swan
1598 – 1602, oil on canvas,
65 × 81 cm, Fogg Art Museum,
Cambridge

❧ Is what was concealed behind this public outrage nothing less than a challenge to our self-image? Part of the answer is already contained in the question: no other creature on Earth ponders the question as to how "animal-like" it is: animals simply are. We are different. We engage in a dialogue with ourselves, with others and with our environment. We can be unnerved or confirmed in our attitude; we become excited and get involved in endless heated debates.

❧ Art forms a part of public discourse, and it is often calculated to provoke. The greatest possible effect can be achieved with the mass media, which often subtly exploit art. Jeff Koons' series of works *Made in Heaven* → **pages 72–73**, created in the 1990s, cast the public in a specific role too, because without an audience Koons would not have been able to make his point. It was, to put it simply: "Look, we enjoy sex, we accept no taboos and we're not ashamed of the fact – on the contrary!"

❧ Koons published large-format photos of himself involved in erotic acts with the politician and pornographic actress Ilona Staller. Eroticism, sex, fantasy and hedonism became their *raison d'être,* which they extolled as a counter to Masaccio's Renaissance fresco *The Expulsion from the Garden of Eden.* Abject wretchedness, shame and feelings of guilt on the one side, unashamed fun and sensuous pleasure on the other.

❧ Koons was not in the least bothered that his interpretation of the banishment from Paradise ingenuously reduced the subject to a single aspect: he was not interested in "examining the question of sin, or lack of it, in depth." Believing in sin only prompted fears, and the aim was to demolish the latter. Koons commented: "People should accept that here we are talking about something which is pure. I believe in purity."

❧ However, not everyone understood his concept of "purity," with the result that the scandal was inevitable. Or was the reason for the indignation rather his all-too-blatant equalisation of pornography and art?

❧ In any case, Jeff and Ilona married in 1991, though they were divorced the following year, their relationship having produced a son.

❧ In retrospect, Koons nonetheless did have something to say about *Made in Heaven*: "Even when my only concern is sexuality, you nonetheless experience a certain transcendence, a sort of spiritual enlightenment. So my work also refers to the infinite – through its links to biology, and having children and passing on one's genes, so to speak the essence of eternity."

❧ Koons now has six children with his second wife. There is a very good chance that many of his genes will have been passed on.

What, then, is this theory of genes really all about? To put it in simplified terms: the Stone Age mammoth hunter and the berry-picking Stone Age woman who looks after the children and the fire are still present today, hidden away inside all of us. It was in those times that our genes developed, and they continue to determine our actions and emotions to this day. It is no wonder, therefore, that the "mammoth hunter" becomes aggressive in a crowded underground train, and it is no wonder, too, that the sight of a sexy woman immediately triggers the predictable physiological response. The genes are functioning as nature intended. Is it perhaps the sort of "relief" to which Jeff Koons referred when he looked back on his series *Made in Heaven* and commented that it had "liberated" him?

The "relief factor" in this genetic theory seems an obvious one. Having recourse to it, full of child-like innocence we can deny all responsibility and simply sweep aside all regulations, norms, reservations, taboos and objections on the part of society, the Church, feminists, and bourgeois notions of morality with a regretful shrug of the shoulders. No more self-destructive brooding, no feelings of guilt, no questioning – just: being! Wonderful.

The problem with this approach, however, lies in answering the question: What should we "be" like? How can we live "in harmony with our genetic programming"? Nobody knows what the sex and love life of Neanderthals as really like, and the great apes, our closest relatives, genetically speaking, follow different behaviour patterns. And so what remains is the return to the theory of evolution: in order to ensure the widest possible distribution of one's own genes in the fight for survival, the natural behaviour of the human male is to "distribute his genes" among as many healthy and attractive female examples of the species as possible. In the interests of caring for her young, on the other hand, the human female pays attention not only to the attractiveness of the genes-provider but also his qualities as a carer. And suddenly it seems crystal-clear what "typically male" and "typically female" mean, doesn't it? Animal-like!

And now the scales fall from our eyes as we realise what mysterious "infinity" and what "essence of eternity" Jeff Koons was really talking about. He is certainly clever. And he has such a disarmingly open, youthful smile – to this day. Over twenty years have passed since then. Recently, during the summer of 2012, the City of Frankfurt made available two exhibition locations for his works: his pictures took over the Schirn Kunsthalle, and his sculptures the Liebighaus. *Made in Heaven* was also shown again; surprisingly, however, this time in a private exhibition, with the risqué parts demurely covered up – at the request of the artist himself.

What should our verdict be on all this? Is it art, pornography or kitsch? Shameless or refreshingly naive? Bold or all too simply designed? Money-grubbing or just randy? After all, Koons's art attracts some of the highest prices on the market. Is it esoteric or smart? Exhibitionistic? There is no doubt about the fact that it is impeccably crafted – even if it was not produced by the artist himself.

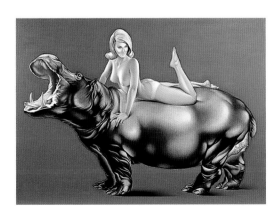

Mel Ramos
Hippopotamus
1967, oil on canvas,
177,8 × 218,14 cm,
private collection

The point about all the borrowings from Darwin is that evolutionary biology itself is already beginning move away from the radical gene theories. Only sociobiologists and the representatives of evolutionary psychology still adhere to it; what else can they do – except die out?

No, we humans have to resign ourselves to the fact that we are complicated. "Love" is not possible without our self-image, our socialisation, our culture, our nature, our individuality, our feelings and our ideas. So love remains a fascinating subject – especially because it is in love that all aspects of our humanity are crystallised. Its stories are always very personal and political at the same time. Coarse *and* poetical. Animal *and* spiritual. Tragic *and* romantic and – often also quite amusing. All this is reflected in art, and how boring it would be if that were not the case!

The **heart** has reasons that reason cannot know.

—— Blaise Pascal

Love in art

Pastiche or parody, burlesque or grotesque, satire or subtle irony – the stylistic possibilities for making fun of ourselves and others are numerous. William Shakespeare was a supreme master of the art.

In his comedy *A Midsummer Night's Dream* he lets the Queen of the Fairies, Titania, murmur amorously "What angel wakes me from my flowery bed?" into a pair of oversized hairy ears. The object of her affection is the coarse, stupid, clown-like weaver Bottom, whom Puck, the mischievous forest sprite, has given an ass's head in jest → **page 39**. But why on earth does Titania fall in love with this ungainly fool?

The audience has been able to follow the plot and look forward to the moment of her awakening: the sleeping Titania was put under the spell of a flower with magical properties. The juice, squeezed onto her eyes, ensured that she fell in love with the first creature she saw upon waking. Puck succeeded in playing a trick on her! Bottom, with his brand-new ass's head, has a singing voice that is anything but melodious – and yet Titania raves:

> I pray thee, gentle mortal, sing again:
> Mine ear is much enamour'd of thy note;
> So is mine eye enthralled to thy shape;
> And thy fair virtue's force perforce doth move me
> On the first view to say, to swear, I love thee.

Bottom replies:

> Methinks, mistress, you should have little reason
> For that: and yet, to say the truth, reason and
> Love keep little company together now-a-days; the
> More the pity that some honest neighbours will not
> Make them friends. Nay, I can gleek upon occasion.

Puck has played this trick on Titania on the instructions of his master, Oberon, the King of the Fairies. He wants to avenge himself on his beloved wife because she will not allow him the possession of an Indian boy in her retinue whom Oberon covets. Bottom, in fact, is currently rehearsing a play about the tragic love of Pyramus and Thisbe with a group of friends, in order to perform it during the upcoming wedding of Duke Theseus with Hippolyta, Queen of the Amazons. And then there are the two youthful couples who refuse to fall in love with the prospective partners chosen for them by their fathers. So they flee into the forest to escape their fathers' authority, where Puck and Oberon add to the confusion with mischief brought about by the magic flower.

Finally, all's well that ends well. *A Midsummer Night's Dream* in the wild forest is over; the couples have been returned to each other and order reigns once more at court, the place of culture and civilisation – what a relief. But in the meantime the fantasy resulting from the confusions and complications in the forest have afforded the audience much merriment.

But what if this wonderfully confusing madness were suddenly to become reality? What if the wild dream were to have no ending and the once-reliable order were suddenly lost? What a nightmare! That is what happened during the era in which Gustav Klimt lived.

Klimt was highly gifted at drawing, possessing a sure hand and a quick eye. He always had a number of models on the spot in his studio, and he liked to relax by sketching them in between sessions → page 12. In doing so he conducted his own personal search: "I am not interested in my own person – I am more interested in other people, women," was one of his curt comments. And he then studied these women very precisely indeed, in every respect.

He (apparently) had children only with models. At the same time, the wives of the prosperous upper bourgeoisie from the new industrial class also liked to sit for him so that he could paint their portrait. His "dearest one," however, with whom he shared his life, was Emilie Flöge. She had curly red hair that was difficult to keep under control. It is easy to believe that she is the female figure in Klimt's famous painting *The Kiss* → page 44. There has been a great deal of speculation as to whether the two of them ever slept together; nothing certain is known. That, too, is a private affair and none of our business. And yet, this circumstance may well express the deep uncertainty that was typical of the time. Nothing, nothing at all, seemed to remain as it had once been; was as it should have been. The Industrial Revolution had brought about fundamental social changes including the rise of the new proletarian class.

The calls for social justice became louder, and increasingly the voices of women were heard as well. They too demanded equality in all issues as their right.

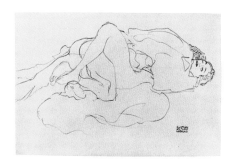

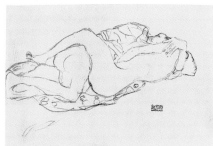

Gustav Klimt
Lovers, facing to the right
1914–1916, pencil on paper,
37.3 × 56 cm,
private collection

Gustav Klimt
Lovers, facing to the right
1914–1916, pencil on paper,
37.3 × 56 cm,
private collection

Most men found it difficult to accept the new self-awareness of women – especially since attacks on their self-image also came from other quarters. In artists' circles the theories of the philosopher Arthur Schopenhauer were the subject of animated debates – above all the claim that our sexuality is determined by instinct, and not by free will!

This was deeply unsettling. "Man is a rational being – or at least, men are rational," had been the unchallenged doctrine until then. On this subject Friedrich Nietzsche declared that Apollo stood for self-control, and Dionysus for intoxication, loss of control and fusion. We can only achieve the greatest intensity by enduring the tension between these two opposing elements within ourselves – which, Nietzsche was firmly convinced, was only possible with the help of intuitive art that was the product of genius.

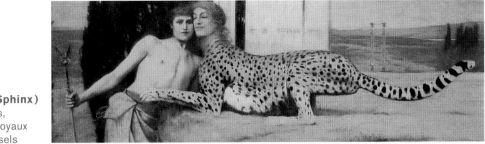

Fernand Khnopff
**Art
(or The Caresses, The Sphinx)**
1896, oil on canvas,
50 × 150 cm, Musées Royaux
des Beaux-Arts, Brussels

What profoundly experienced lack of control was being disseminated here! Because with the powerful longing for loss of control in the "fusion" with a woman was linked at the same time the deep-seated fear of being at her mercy. The *femme fatale* began to haunt art studios and theatre stages. The figure of the Sphinx → page 13, 63 embodied the mysterious nature of women and the danger they posed to men. In Greek mythology the Sphinx is a chimera with the body of a winged lion and a woman's head, and is thus anything but enchanting. She spent her time confronting all those who passed through Thebes and crossed her path with the famous "Riddle of the Sphinx": "What walks on four legs in the morning, two legs at noon and three legs in the evening?" No one could give the correct answer, so that they were all devoured by the monster. Only Oedipus discovered the solution: "It is man." Whereupon the Sphinx plunged from her rock into the abyss, and Thebes was finally free of the terrible creature.

Largely following in the tracks of the "impenetrable" and the "incomprehensible," Symbolist artists used new means of expression to explore themes with a new intensity and obsession: dreams, ecstasy, disturbing emotions, illness, death, sin, passion. Edvard Munch put it thus: "The camera can't compete with paintbrush and palette as long as it cannot be used in heaven and hell." But: How does one *paint* love – an emotion?

The need for a new spirituality had arisen as the antithesis to the new materialism of the time. Inspiration came from the doctrines of the Far East, together with theosophy and occultism – as in the works of the Belgian painter Jean Delville. It was in this spirit that Delville arrived at his version of *L'Amour des Ames* (The Love of Souls) → page 71.

Voluptuous passion

Camille Claudel lived at the same time as Gustav Klimt. Even as a child she carted sacks of red earth home from the surrounding woods because it was ideal for kneading and forming into shapes. He mother disapproved, but her father supported Camille and was even proud of her waywardness, her passionate temperament and her artistic drive. She would need all those qualities on the path she chose to follow.
Her chosen career as a sculptor had hitherto been a male domain – even more so than painting. No matter! She decided that it would become *her* domain! Because art, especially sculpture, was her life.

❧ In Paris, Claudel met Auguste Rodin, and soon love also became part of her life, along with art. It was a matter of sensuousness and passion, of *feeling* and exploring bodies, in life as well as in sculpture. Learning and teaching, learning by watching each other, discussing and investigating – all that became part of their life together.
It was unimportant to her that Rodin was twenty-four years older than she was. But how lonely she was whenever he left her to return to Rose Beuret, his companion of many years. Claudel expressed these emotions in her sculpture *Maturity*.

❧ Claudel put into her sculptures all that she observed, felt and experienced. This, for her, was the only way of creating art. Of course, in doing so she exposed her innermost thoughts. Her feelings were visible for all to see. Claudel's sculptures are accordingly as expressive as they are authentic. One of her main works is *The Waltz* → **page 46;** in it she has succeeded in giving movement a form so that it seems as if the couple will continue to sway and turn for ever in their passionate dance of love. Claudel experienced this dance herself in one of her moments with the composer Claude Debussy, as the two of them wandered together through the streets of Paris at night.

The enchantment of love

"In the morning and at night she brought me sweet home-baked cakes to my studio, fried fish, hot milk, coloured fabrics and even boards which I could use as my easel. I had only to open my window and the blue sky, love and flowers poured in when she visited me. Dressed entirely in either white or black, she haunted my pictures for a long time as the model for my art." Thus Marc Chagall wrote of his wife Bella in his book *My Life*. In fact, such words are largely superfluous – we can simply look at his paintings and drawings. Expressing his emotions directly, he brings an involuntary smile to our faces. How? That is his art.

For want of a better classification, Chagall is often referred to as a Surrealist. Perhaps because he shows the people whom he loves flying through the air? Because his longing for Bella is so great that he begins to fly himself? → **page 97** After all, that is not truly "real" – or is it?

⚘ He, a poet of pictures and of words. He simply takes the latter literally: the artist actually hovers, then, in "seventh heaven" → page 40, holding the hand of his beloved Bella. He always adds a generous portion of naivety, cheerfulness and a great deal of lively charm – all seasoned in most cases with a pinch of humour.

⚘ But not even the ghost of a smile would cross our lips if the picture did not radiate that spark of his personality, which then leaps out towards us – his own unique character. And how does he achieve every time – that spark of individuality? Well, that again is his art – and according to Chagall that is due in no small part to loving and living.

Always the same course of love?

Perhaps Chagall enchants us to such an extent because he seems to defy so effortlessly the merciless grip of everyday life. Undaunted, he places yet another pair of lovers in the lilac bush, marries them off, allows them withstand the turmoil of fate together. Everyday routine? He seems not to have encountered that – at least not when it comes to love.

⚘ So many love stories end with the first kiss; they have found each other and will live happily ever after! After that – well, we know what always happens then – and it is better not to talk about it.

⚘ Really not? In Pablo Picasso's *Two Saltimbanques* we can see it, the unexciting "after," and he does indeed show it with great intimacy → page 16. Is this the other side of the coin?

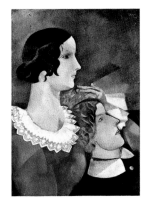

Marc Chagall
Lovers in Grey
1916 / 17, oil on paper,
Centre Pompidou,
Musée National
d'Art Moderne, Paris

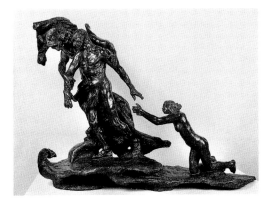

Camille Claudel
Maturity (second version)
1894 – 1899, 1902, bronze,
114 × 163 cm ,
Musée d'Orsay, Paris

❧ Pictures and sculptures can be like snapshots. Change and narrative, on the other hand, can be better shown in novels and films. In 1962 Edward Albee's drama *Who's Afraid of Virginia Woolf* caused a sensation: it mercilessly tells the gruelling story of the delusions and mutual humiliations of two married couples. Eleven years later the Swedish film director Ingmar Bergman followed with *Scenes from a Marriage*.

❧ Yes, even subtle mutual cruelty and helplessness are exposed nowadays. Perhaps that is why it is so moving and so remarkable when we see examples of love that has survived the vicissitudes of life.

"Till death us do part"? In view of the progress of modern medicine, nowadays that is likely to be a very long time. Indeed, we are all living longer, our demands for a life of pleasure are constantly increasing, and our economic situation usually makes us independent and self-sufficient.

To be there for each other "for better, for worse" – is that a pious dream nowadays? Perhaps. But if we look around us we can still find here and there examples of togetherness that are deeply felt and experienced, even in our own circles. Is that what gives us hope? Is that what encourages us to "take the plunge" – these stories which we also like to tell each other? Even today there are examples of couples who live in the public eye, and there are others whose stories are told on the cinema screen – without sentimentality and saccharine dewy-eyed kitsch. One example is the film *Amour,* written and directed by Michael Haneke, and awarded the Golden Palm in Cannes during the summer of 2012. The film tells the story of a married couple, Anne and Georges, at the end of their lives, when she is afflicted by a series of strokes and then dementia. Their love is not exciting, but it is profound and real, and it stands the test – one last time.

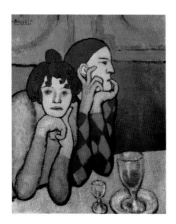

Pablo Picasso
The Two Saltimbanques: Harlequin and his Companion
1901, oil on canvas,
73 × 60 cm,
Pushkin-Museum, Moscow

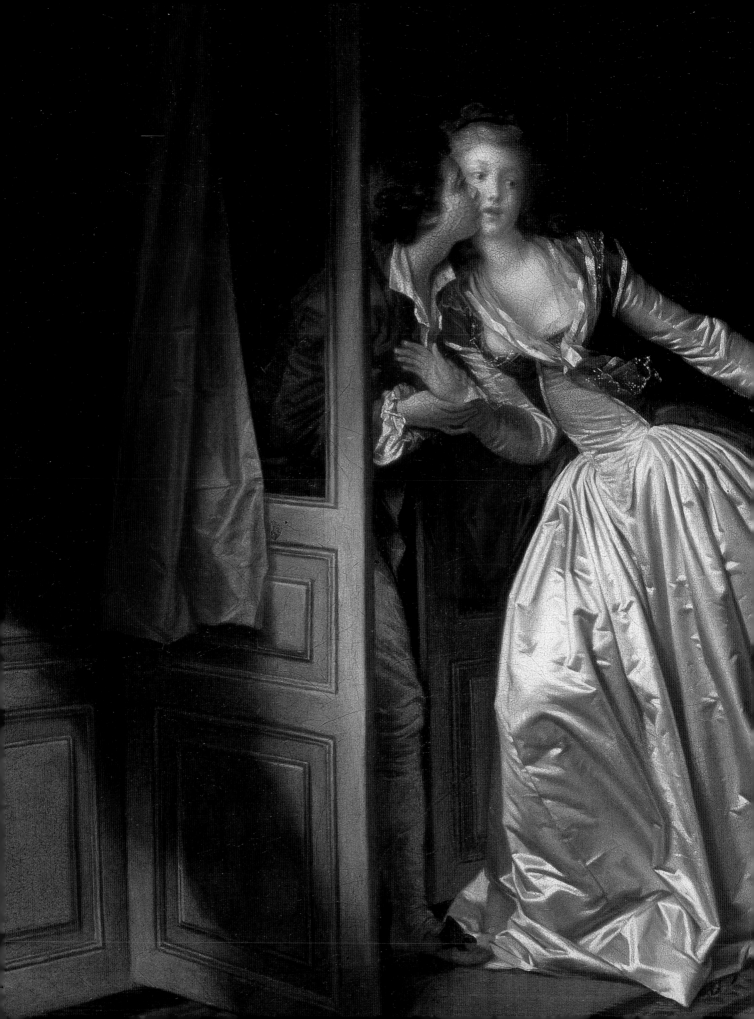

And ever has it been
known that love knows not
its own depth until
the hour of **separation**.

—— Khalil Gibran

If a woman wants to hold a man, she has merely to appeal to what is worst in him. We make gods of men, and they leave us. Others make brutes of them and they fawn and are faithful.

—— Oscar Wilde,
from **Lady Windermere's Fan**

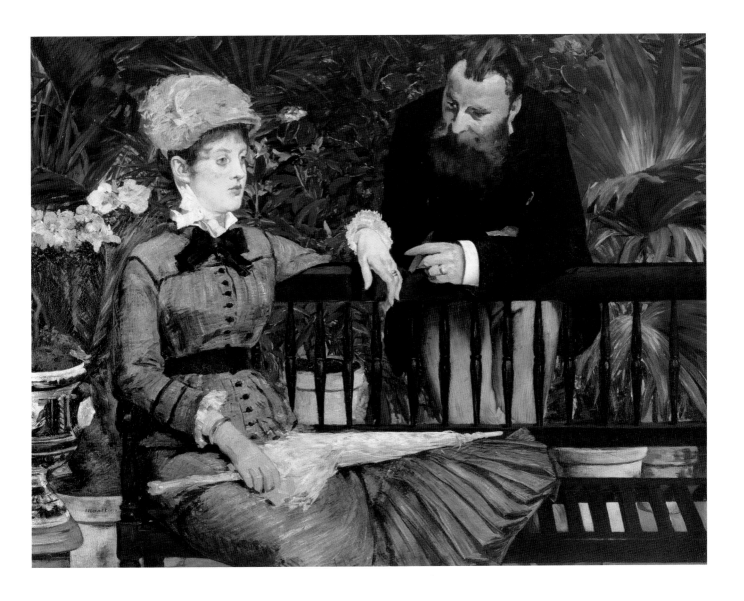

Édouard Manet
In the Conservatory
1879, oil on canvas, 115 × 150 cm,
Alte Nationalgalerie,
Staatliche Museen zu Berlin, Berlin

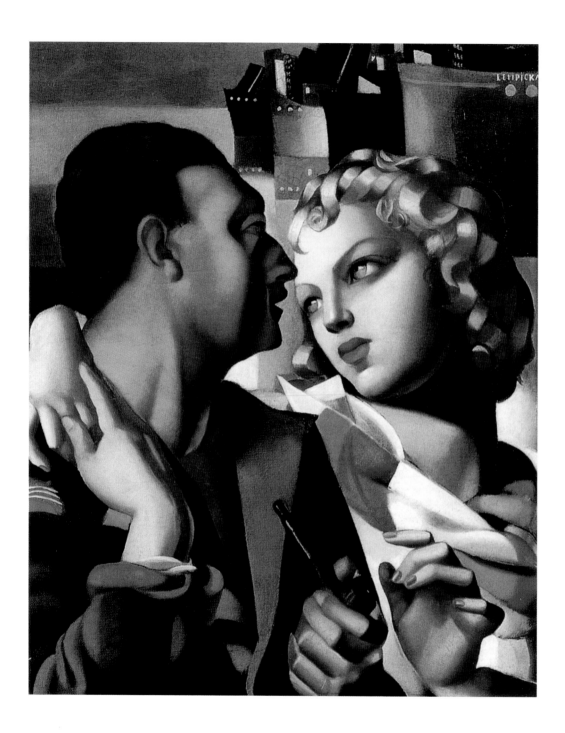

Tamara de Lempicka
Idyll
1931, oil on wood, 41 × 33 cm,
private collection

The feeling of love is among the **greatest** and eternal aspects one discovers in the human spirit. It is remarkable in that it survives under all circumstances and trials, it always retains its appeal in the sphere of art…

—— Chingiz Aitmatov,
Foreword to **Jamilia**

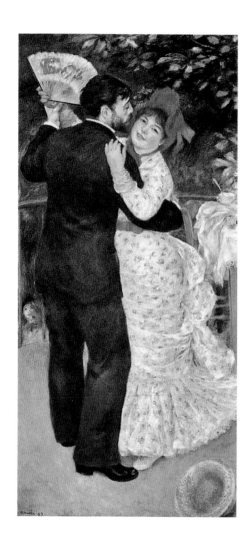

Auguste Renoir
Country Dance
1882 / 83, oil on canvas,
180 × 190 cm,
Musée d'Orsay, Paris

Ladies, start to dance.
Keep to the beat and then
kiss the one
you are willing **to love.**

—— Old French Dance

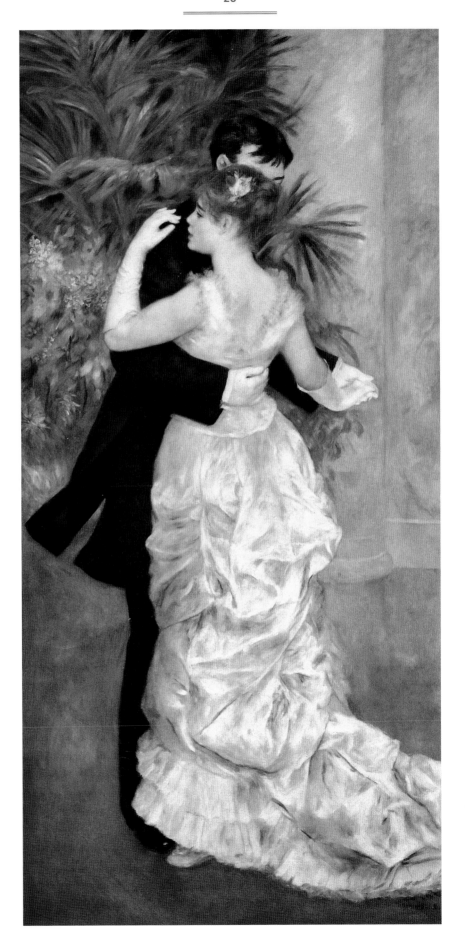

Auguste Renoir
City Dance
1882 / 83, oil on canvas,
180 × 190 cm,
Paris, Musée d'Orsay

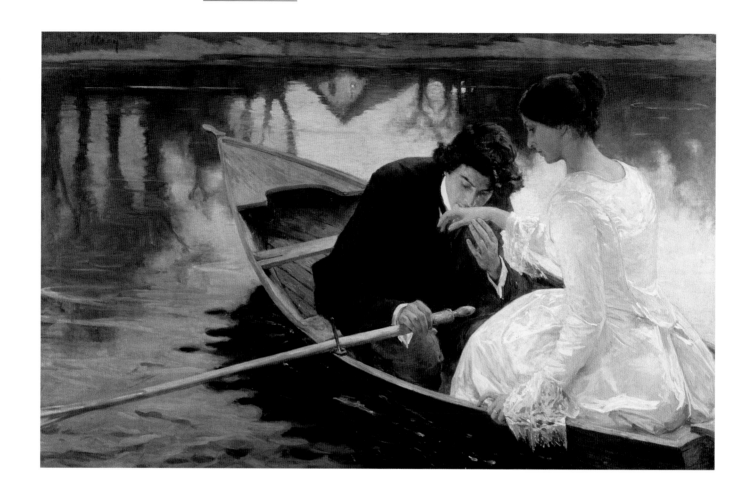

There is nothing more **tenacious** on earth than a lover.

——— Propertius, from **Elegies**

Franz Guillery
Reverie
Undated, painting on canvas,
106.7 × 170.2 cm,
private collection

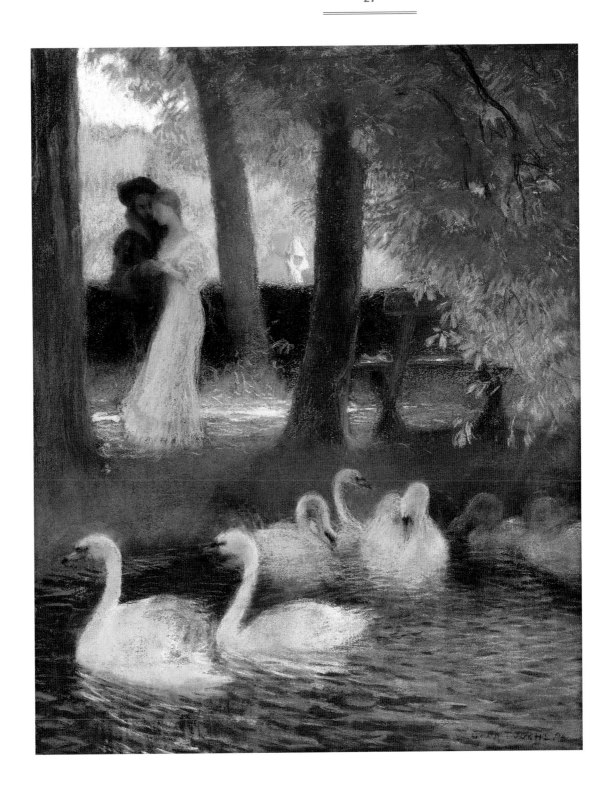

Gaston de Latouche
**A Couple and Swans
(The Autumn Walk)**
1896, pastel on paper,
74.3 × 60.3 cm,
Christie's Images Ltd

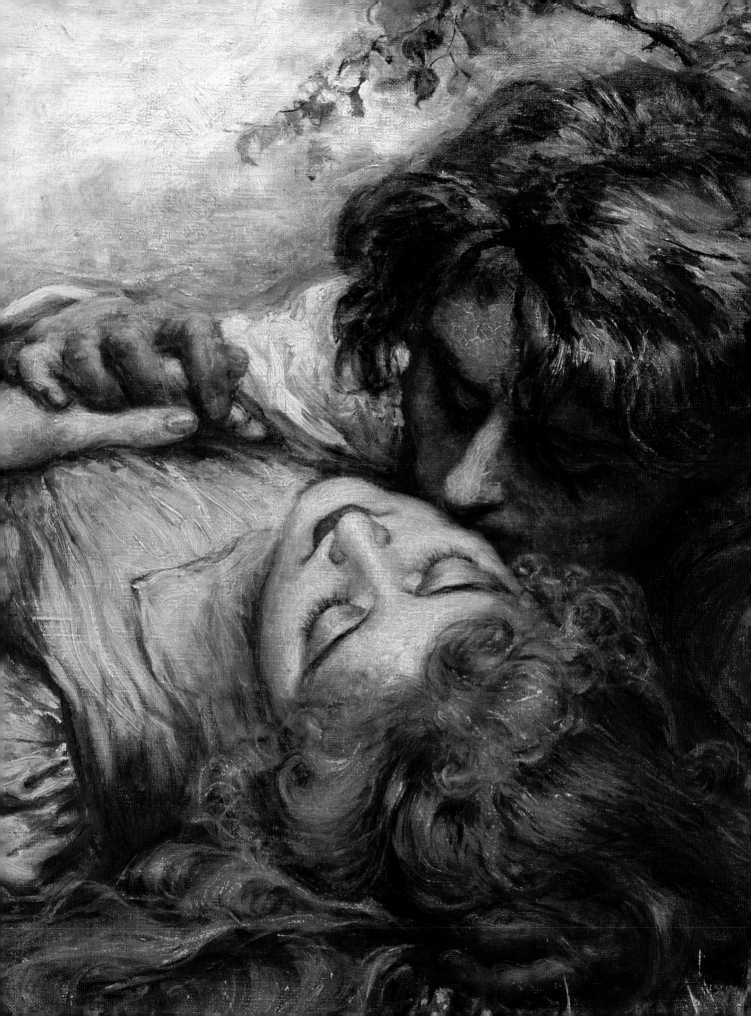

Let thy love in kisses **rain** on my lips and eyelids pale.

—— Percy Bysshe Shelley

Henry John Stock
The Kiss
1894, oil on canvas,
Christie's Images Ltd

Love Song

❧

How may I hold my soul that it refrain
from touching yours? How may I lift it clear
beyond the thought of you to other things?
Oh – dearly I would wish to lay it there
beside the lost and dark and alien,
in some deep, tranquil place too far from here
to answer, trembling, to your depths' trembling.
But all that touches us, your life and mine,
sounds as a bow upon a violin,
drawing the voice in which two strings are one.
What is the instrument that holds us spanned?
And what musician has us in his hand?
O sweet song.

Rainer Maria Rilke

Gustave Courbet
Lovers in the Country
1844, oil on canvas,
77 × 60 cm,
Musée des Beaux-Arts, Lyon

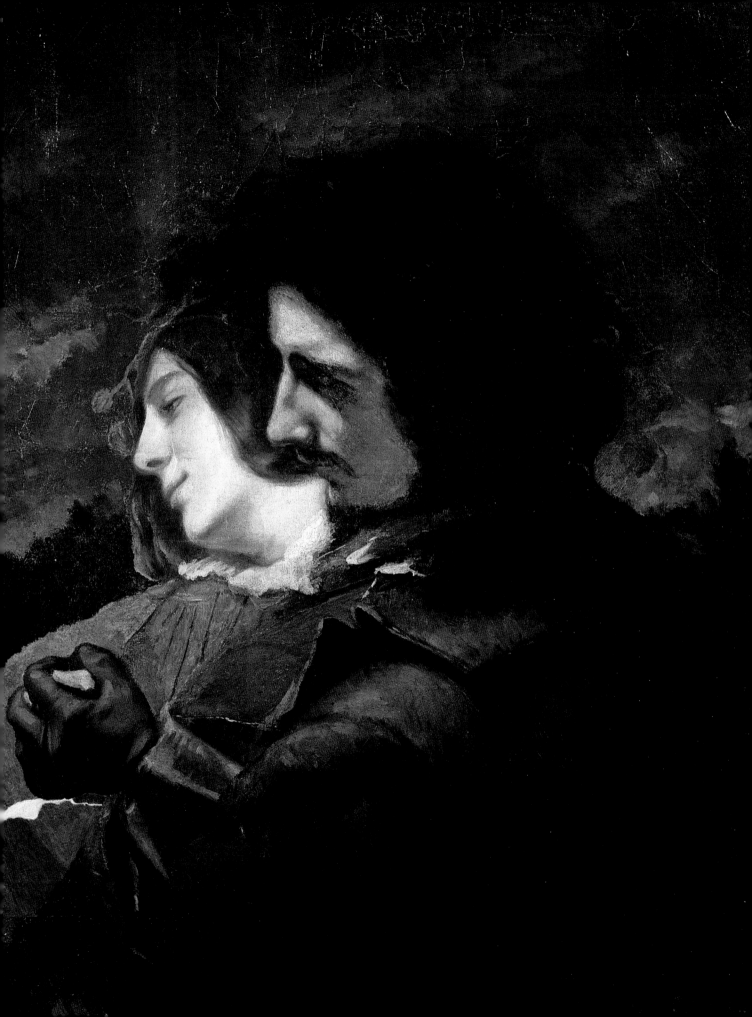

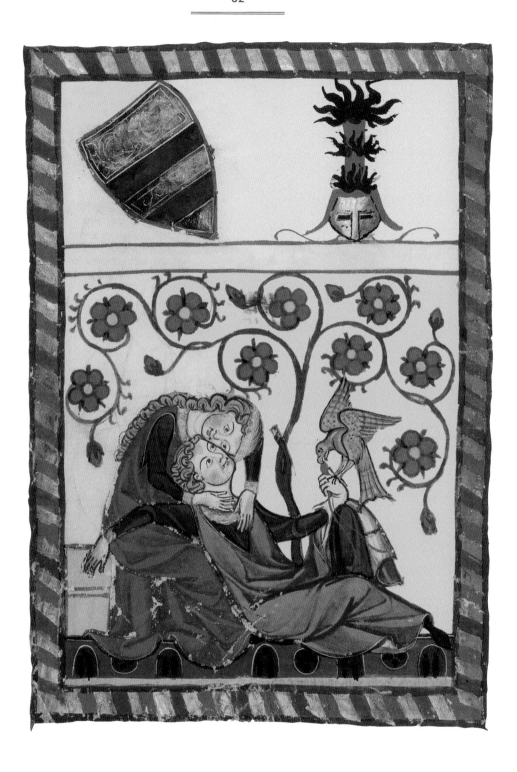

Konrad von Altstetten
Embracing Couple
miniature in Codex Manesse
1305 – 1340, opaque pigment on
parchment, 35.5 × 25 cm,
Heidelberg, Universitätsbibliothek

❧

Under the lime tree
On the heather,
Where we had shared a place of rest,
Still you may find there,
Lovely together,
Flowers crushed and grass down-pressed.
Beside the forest in the vale,
Tándaradéi,
Sweetly sang the nightingale.

I came to meet him
At the green:
There was my truelove come before.
Such was I greeted –
Heaven's Queen! –
That I am glad for evermore.
Had he kisses? A thousand some:
Tándaradéi,
See how red my mouth's become.

There he had fashioned
For luxury
A bed from every kind of flower.
It sets to laughing
Delightedly
Whoever comes upon that bower;
By the roses well one may,
Tándaradéi,
Mark the spot my head once lay.

If any knew
He lay with me
(May God forbid!), for shame I'd die.
What did he do?
May none but he
Ever be sure of that – and I,
And one extremely tiny bird,
Tándaradéi,
Who will, I think, not say a word.

Walter von der Vogelweide

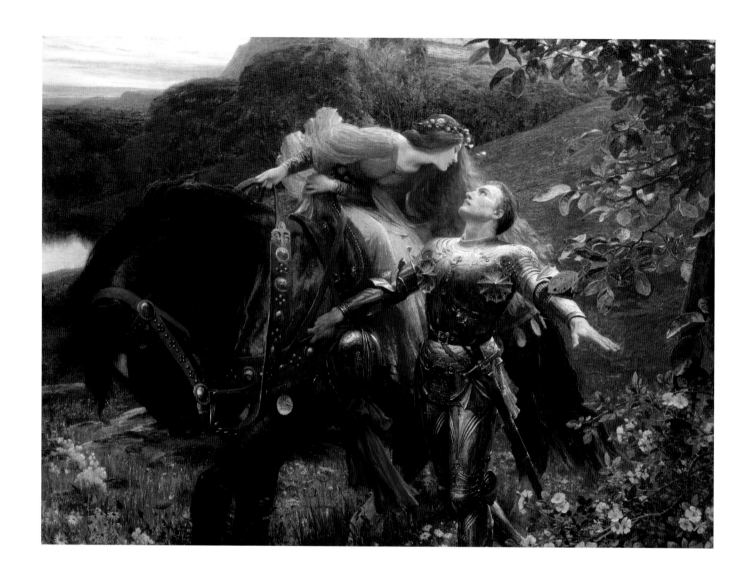

Sir Frank Dicksee
La Belle Dame Sans Merci
1902, oil on canvas,
137.1 × 187.9 cm, Bristol City Museum
and Art Gallery, Bristol

John Everett Millais
The Black Brunswicker
1859 / 60, oil on canvas, 104 × 68.5 cm,
Lady Lever Art Gallery,
Port Sunlight Village, Merseyside

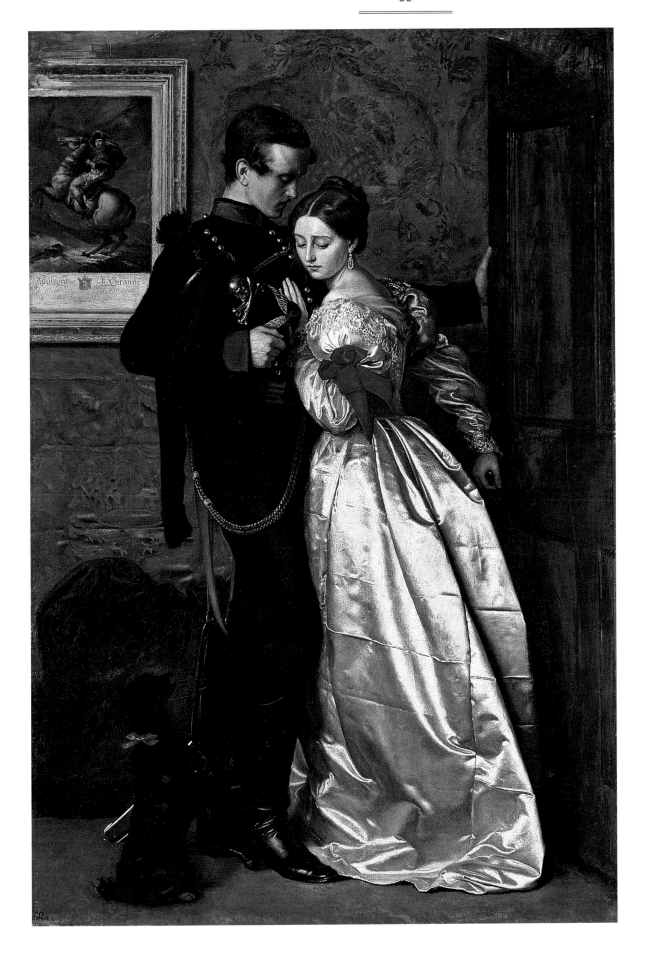

Like **music** on the waters is thy sweet voice to me.

—— George Gordon, Lord Byron, from **For Music**

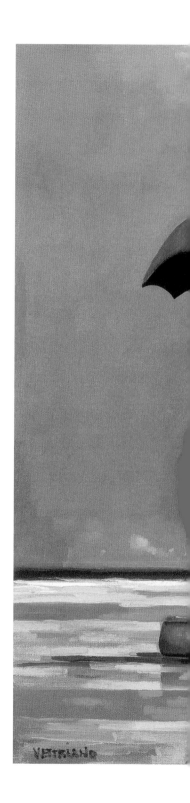

Jack Vettriano
The Singing Butler
1992, oil on canvas, 71 × 91 cm,
private collection, Scotland
© Jack Vettriano 1992,
courtesy of the artist

I try to fill my arms with her **loveliness**, to plunder her sweet smile with kisses, to drink her dark glances with my eyes.

—— Rabindranath Tagore

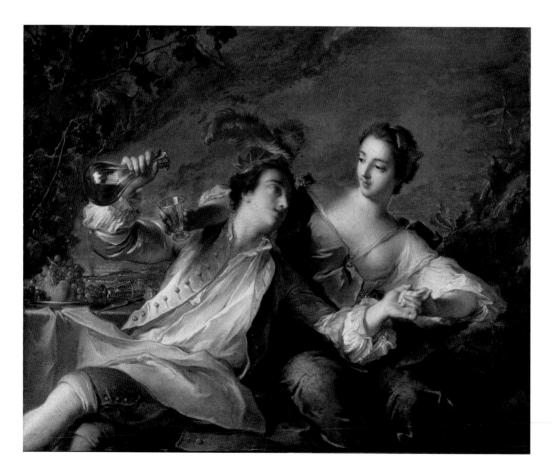

Jean Marc Nattier
The Lovers (Gallant Scene)
1744, oil on canvas,
58 × 74 cm,
Alte Pinakothek, Munich

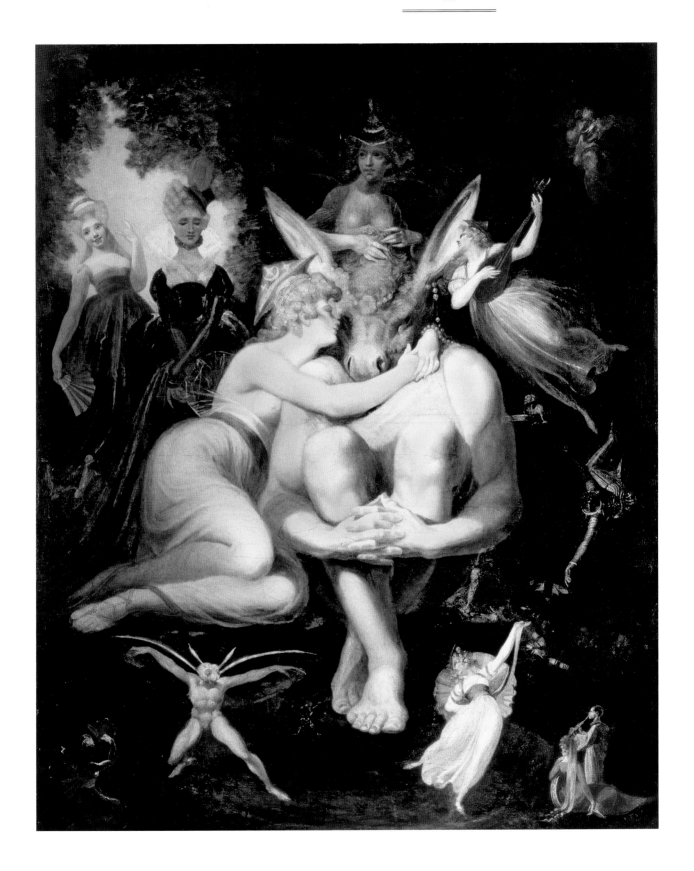

Henry Fuseli
Titania Awakening
1793 / 94, oil on canvas, 169 × 135 cm,
Kunsthaus, Zurich

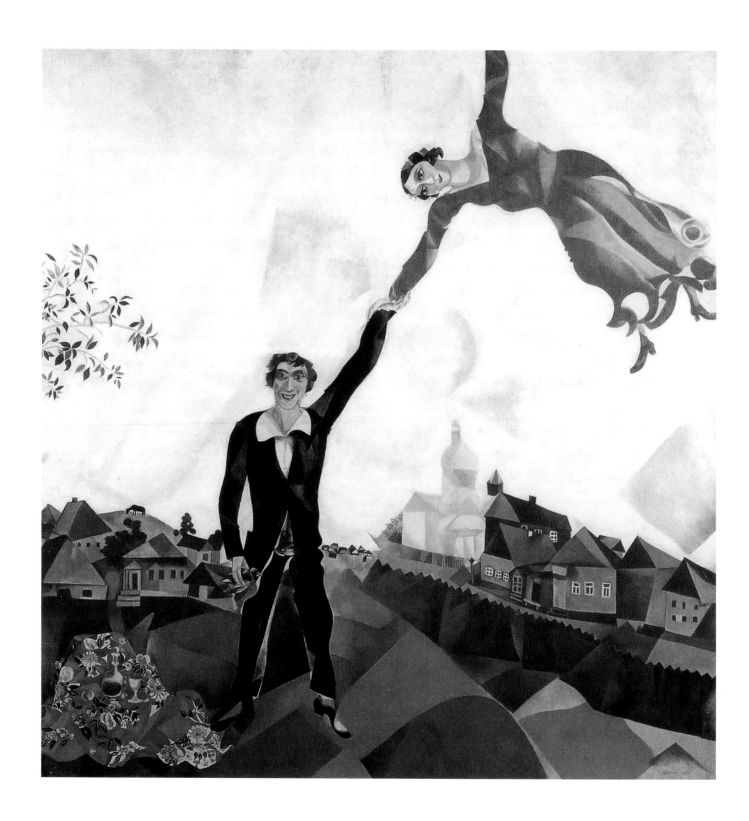

Marc Chagall
The Promenade
1917/18, oil on board, 170 × 163.5 cm,
The Russian Museum, St Petersburg

Happiness lies in your ability to love others.

—— Leo Tolstoy

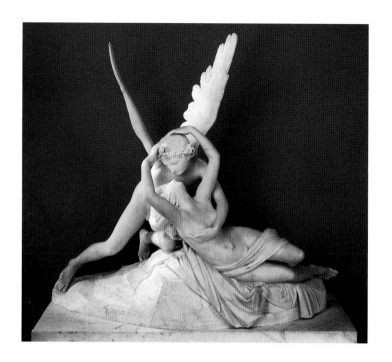

◀ Antonio Canova
Cupid and Psyche
1787–1793, marble, height: 155 cm,
The Hermitage, St Petersburg

François Gérard
Psyche and Cupid
1797, oil on canvas,
186 × 132 cm,
Musée du Louvre, Paris

This is love: to fly toward
a **secret sky,** to cause
a hundred veils to fall each
moment. First to let
go of life. Finally, to take
a step without feet.

—— Rumi

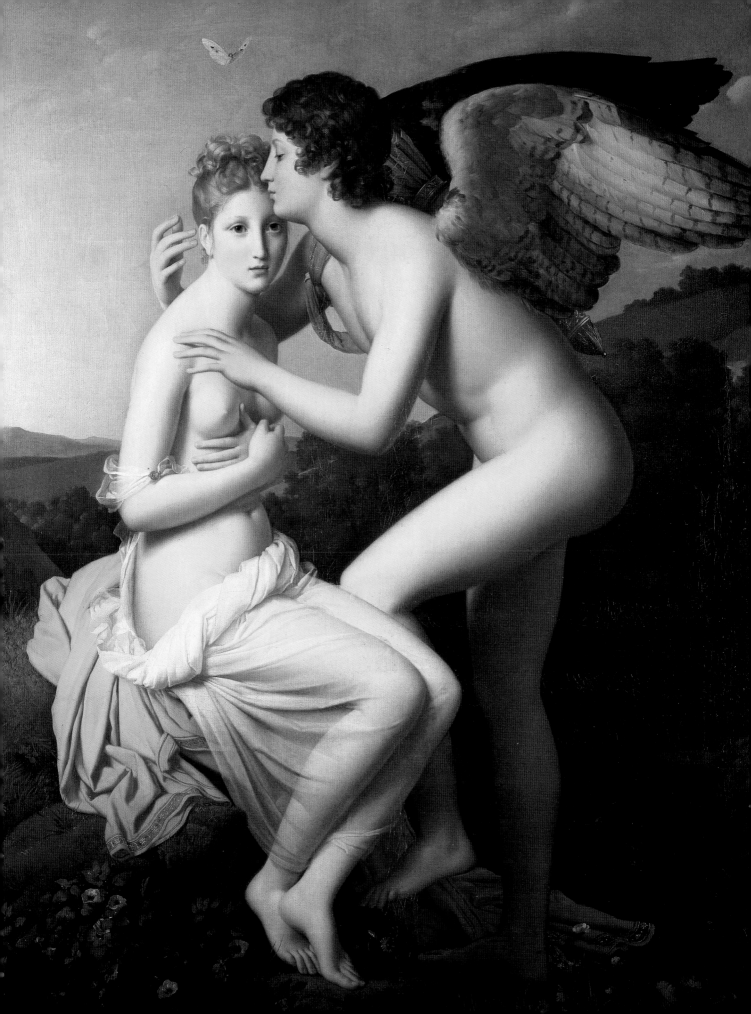

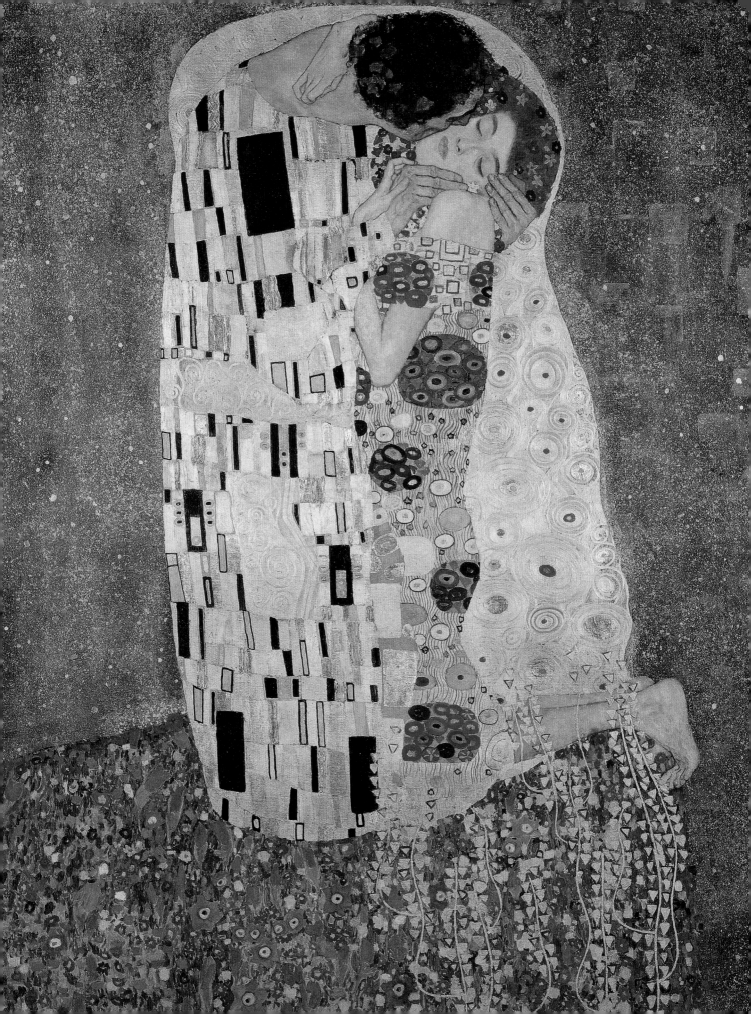

Sonnet 43

᧐

How do I love thee? Let me count the ways.
I love thee to the depth and breadth and height
My soul can reach, when feeling out of sight
For the ends of being and ideal grace.
I love thee to the level of every day's
Most quiet need, by sun and candle-light.
I love thee freely, as men strive for right.
I love thee purely, as they turn from praise.
I love thee with the passion put to use
In my old griefs, and with my childhood's faith.
I love thee with a love I seemed to lose
With my lost saints. I love thee with the breath,
Smiles, tears, of all my life; and, if God choose,
I shall but love thee better after death.

Elizabeth Barrett Browning

Gustav Klimt
The Kiss
1907 / 08, oil, silver and gold leaf
on canvas, 180 × 180 cm,
Österreichische Galerie Belvedere,
Vienna

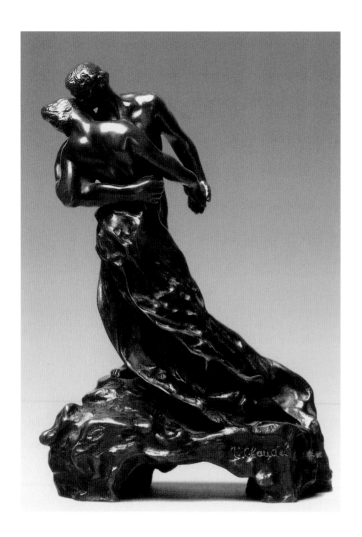

The Lovers

&

See how in their veins all becomes spirit:
into each other they mature and grow.
Like axles, their forms tremblingly orbit,
round which it whirls, bewitching and aglow.
Thirsters, and they receive drink,
watchers, and see: they receive sight.
Let them into one another sink
so as to endure each other outright.

Rainer Maria Rilke

Camille Claudel
The Waltz
1891–1905, bronze,
height: 25 cm,
Neue Pinakothek, Munich

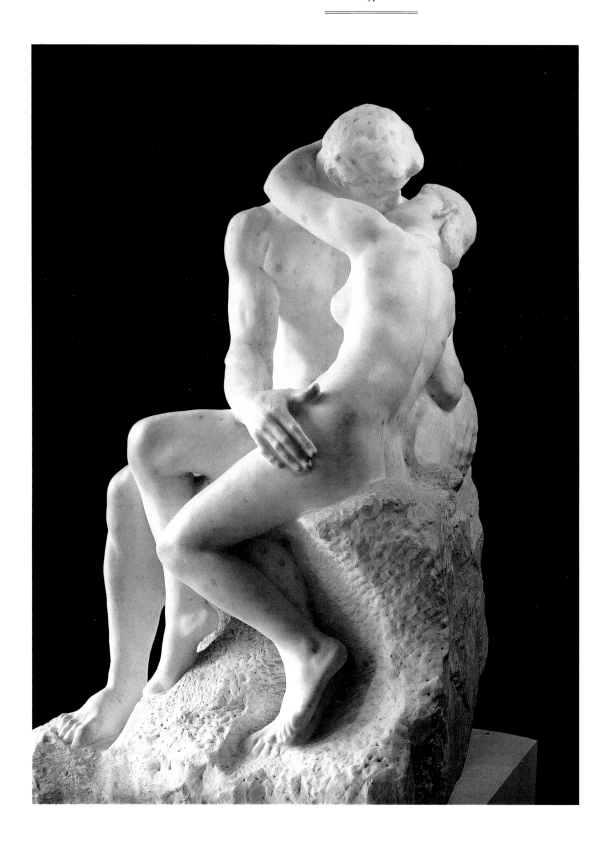

Auguste Rodin
The Kiss
1888 – 1898, marble,
183 × 110.5 × 118 cm,
Musée Rodin, Paris

What is a kiss?
Is it not the **burning** desire
to breathe in part of the
beloved?

—— Giacomo Casanova

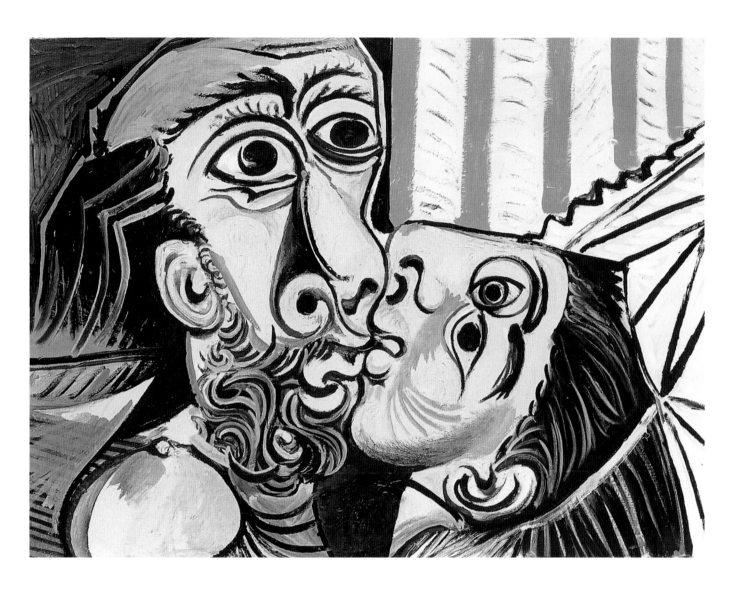

Pablo Picasso
The Kiss
1969, oil on canvas,
97 × 130 cm,
Musée Picasso, Paris

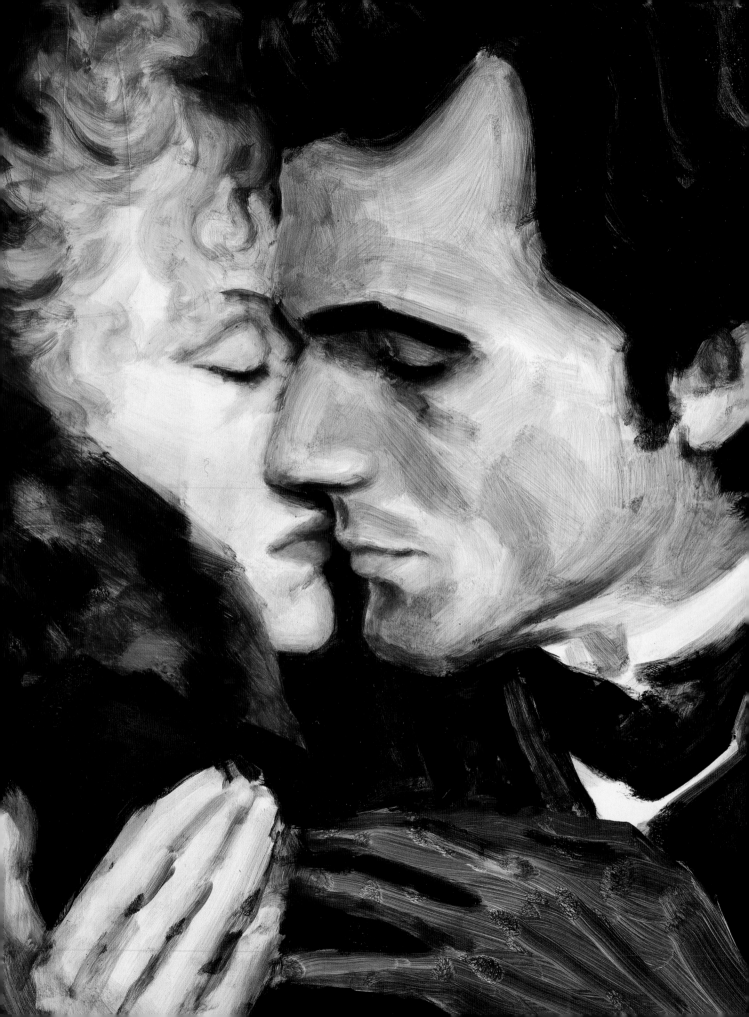

On Love

When love beckons to you,
follow him,
Though his ways are hard
and steep.
And when his wings
enfold you yield to him,
Though the sword
hidden among his pinions
may wound you.
And when he speaks to you
believe in him,
Though his voice may shatter
your dreams as the north
wind lays waste the garden.

—— Khalil Gibran

Elizabeth Peyton
The Age of Innocence
2007, oil on board, 36.2 × 25.4 cm,
Courtesy the artist and
neugerriemschneider, Berlin

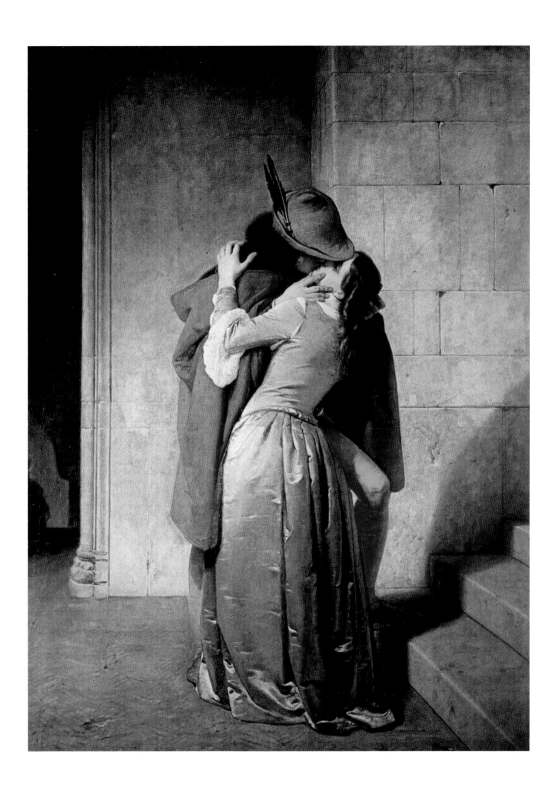

Francesco Hayez
The Kiss
1859, oil on canvas, 112 × 90 cm,
Galleria di Brera, Milan

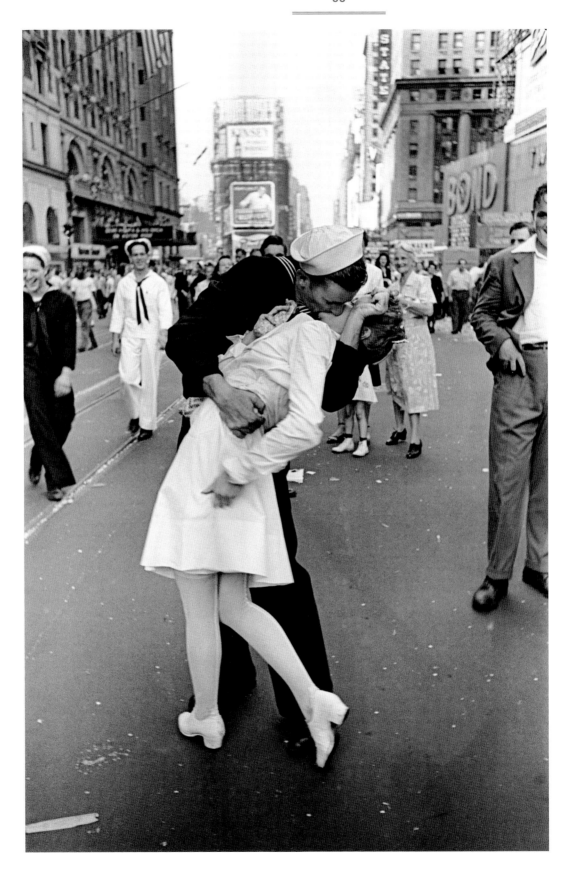

Alfred Eisenstaedt
V-J Day in Times Square
1945, photograph

As in the soft
and sweet eclipse,
When soul meets **soul**
on lovers' lips.

—— Percy Bysshe Shelley,
from **The Moon**

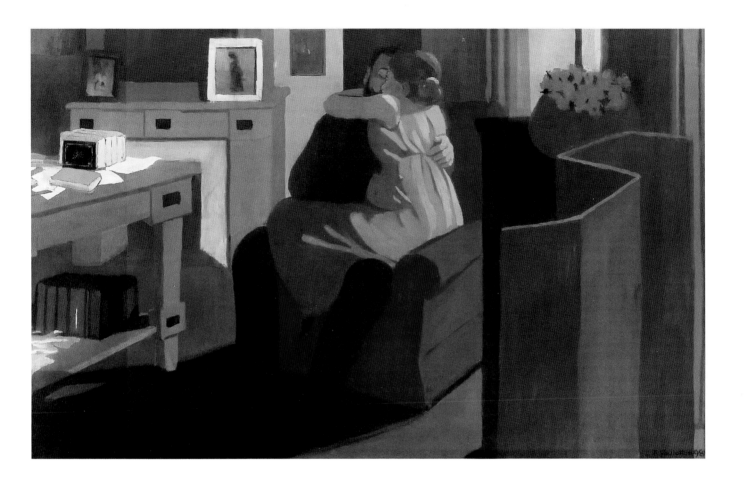

Felix Vallotton
**Intimate Scene: Couple in an
Interior with a Partition**
1898, tempera on board, 35 × 57 cm,
Collection Josefowitz, Lausanne

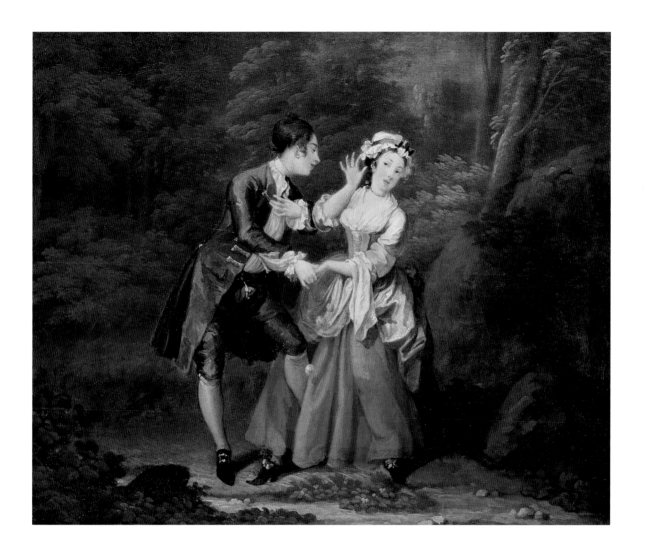

William Hogarth
Before
1730 / 31, oil on canvas,
37.2 × 44.7 cm,
Fitzwilliam Museum, Cambridge

William Hogarth
After
1730 / 31, oil on canvas,
37.2 × 44.7 cm,
Fitzwilliam Museum, Cambridge

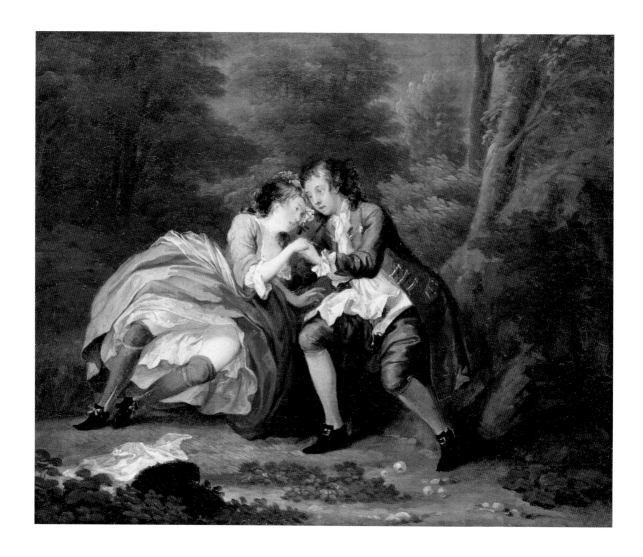

Gather ye rosebuds while ye may,
Old Time is still a-flying:
And this same flower that smiles to-day
To-morrow will be dying.

Robert Herrick,
from **To the Virgins, to make**
much of Time

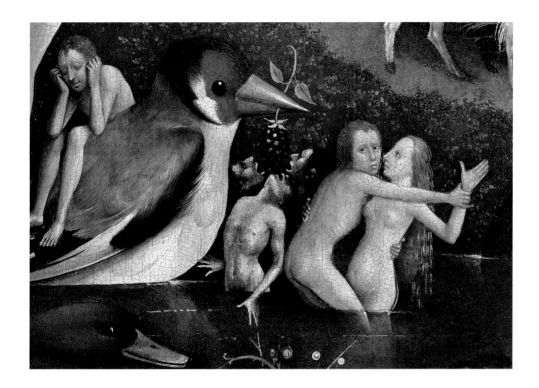

Hieronymus Bosch
**The Garden of Earthly
Delights (detail)**
1480 – 1490, oil on wood,
220 × 389 cm,
Museo Nacional del Prado,
Madrid

Some portion
of **paradise** still is on earth,
And Eden revives
in the first kiss of love.

—— George Gordon, Lord Byron,
from **The First Kiss of Love**

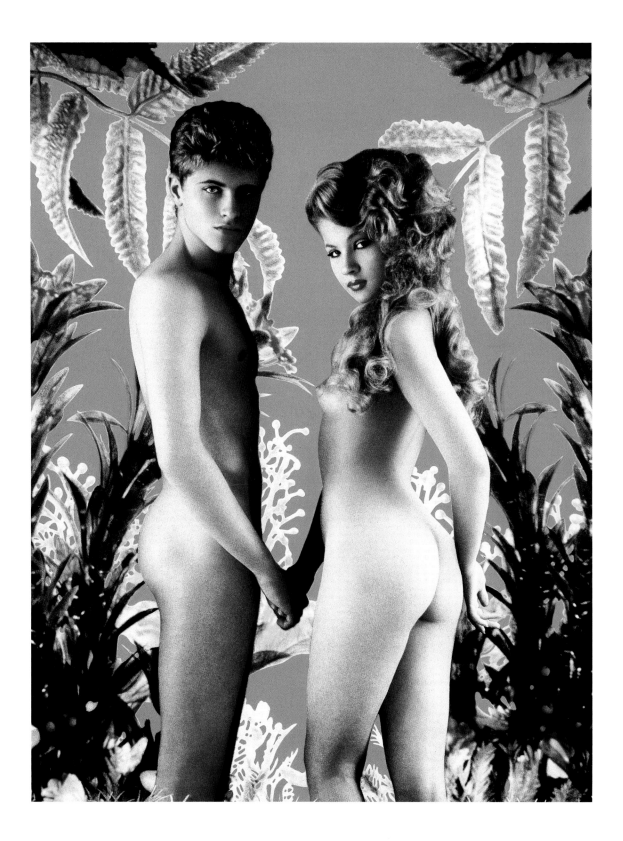

Pierre et Gilles
Adam and Eve
1981, hand-coloured photograph,
40.7 × 31.3 cm

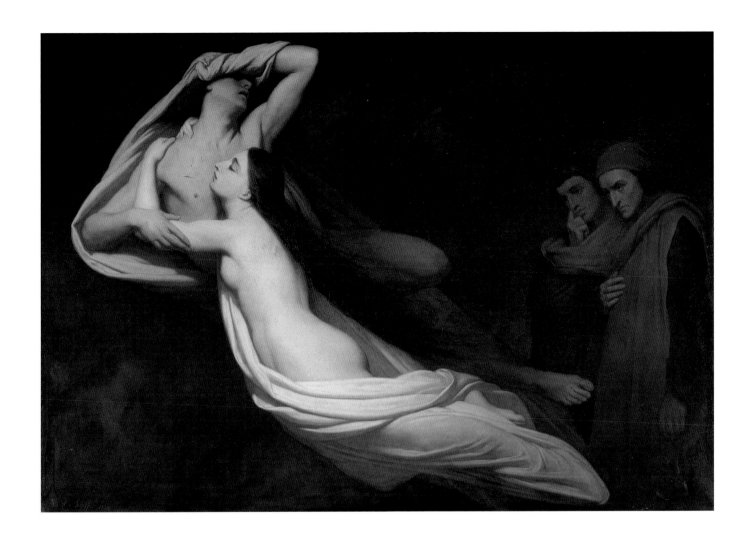

Ary Scheffer
**The Shades of Francesca da Rimini
and Paolo Malatesta**
1855, oil on canvas,
171 × 239 cm, Musée du Louvre, Paris

Dante Gabriel Rossetti
**Paolo Malatesta and
Francesca da Rimini**
1855, watercolour on paper,
25.4 × 44.9 cm, Tate Britain, London

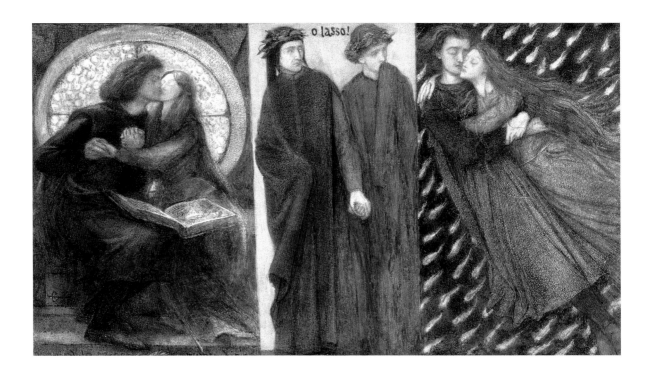

❦

[…] For our delight we read of Lancelot,
How him love thrall'd. Alone we were, and no
Suspicion near us. Oft-times by that reading
Our eyes were drawn together, and the hue
Fled from our alter'd cheek. But at one point
Alone we fell. When of that smile we read,
The wished smile so raptorously kiss'd
By one so deep in love, then he, who ne'er
From me shall separate, at once my lips
All trembling kiss'd.
[…]
In its leaves that day
We read no more.

Dante Alighieri,
from **The Divine Comedy**

Perfect Woman

❧

She was a phantom of delight
When first she gleam'd upon my sight;
A lovely apparition, sent
To be a moment's ornament;
Her eyes as stars of twilight fair;
Like twilight's, too, her dusky hair;
But all things else about her drawn
From May-time and the cheerful dawn;
A dancing shape, and image gay,
To haunt, to startle, and waylay.

I saw her upon nearer view,
A Spirit, yet a Woman too!
Her household motions light and free,
And steps of virgin liberty;
A countenance in which did meet
Sweet records, promises as sweet;
A creature not too bright or good
For human nature's daily food;
For transient sorrows, simple wiles,
Praise, blame, love, kisses, tears, and smiles.

And now I see with eye serene
The very pulse of the machine;
A being breathing thoughtful breath,
A traveller between life and death;
The reason firm, the temperate will,
Endurance, foresight, strength, and skill;
A perfect Woman, nobly plann'd,
To warn, to comfort, and command;
And yet a Spirit still, and bright
With something of angelic light.

William Wordsworth

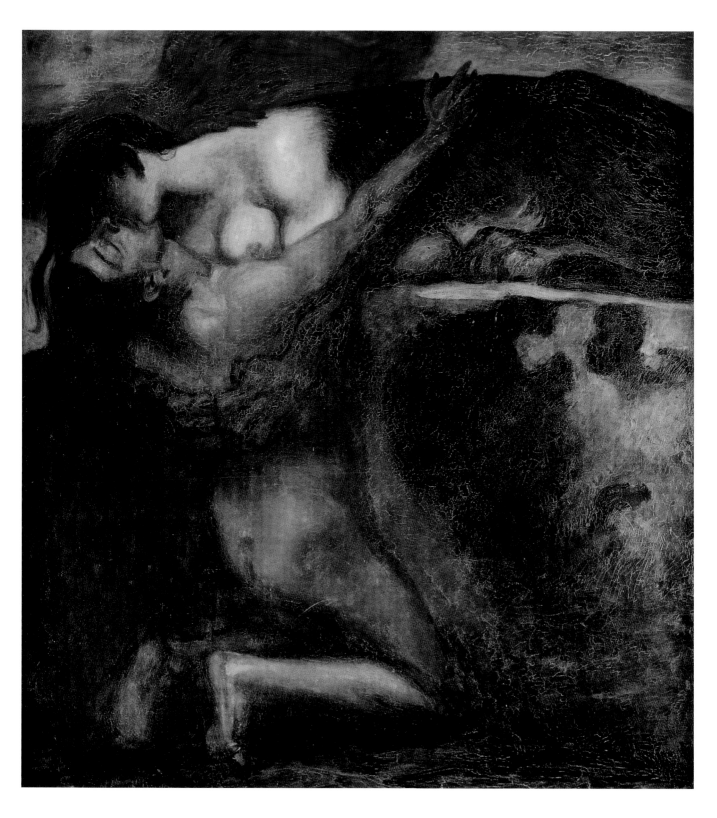

Franz von Stuck
The Kiss of the Sphinx
c. 1896, oil on canvas,
160 × 144.8 cm,
Museum of Fine Arts, Budapest

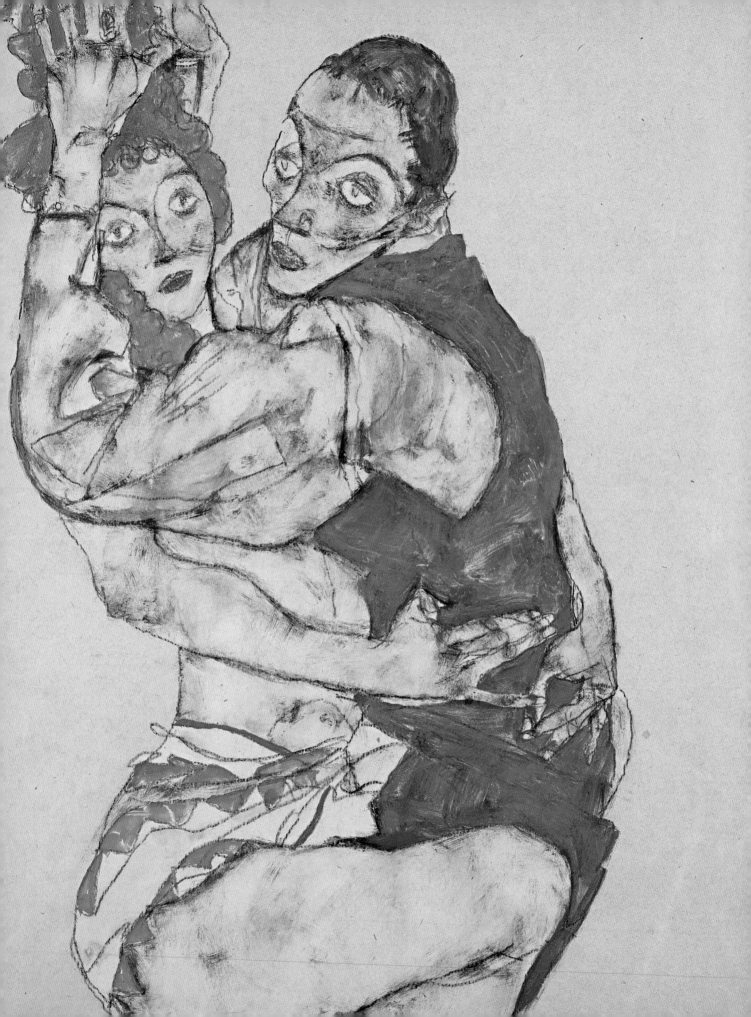

Edvard Munch
Vampire (Love and Pain)
1893, oil on canvas,
80.5 × 100.5 cm,
Museum of Art, Gothenburg

What is a **kiss?**
The licking of flames…

—— Victor Hugo

◀ Egon Schiele
Love Act
1915, gouache and pencil
on paper, 49.6 × 31.7 cm,
Leopold Museum, Vienna

WE
ROSE UP
SLOWLY
...AS IF
WE DIDN'T
BELONG
TO THE
OUTSIDE
WORLD
ANY
LONGER
...LIKE
SWIMMERS
IN A
SHADOWY
DREAM ...
WHO
DIDN'T
NEED TO
BREATHE...

Roy Lichtenstein
We Rose up Slowly
1964, oil and Magna on canvas,
172.7 × 233.7 cm,
Museum für Moderne Kunst,
Frankfurt am Main

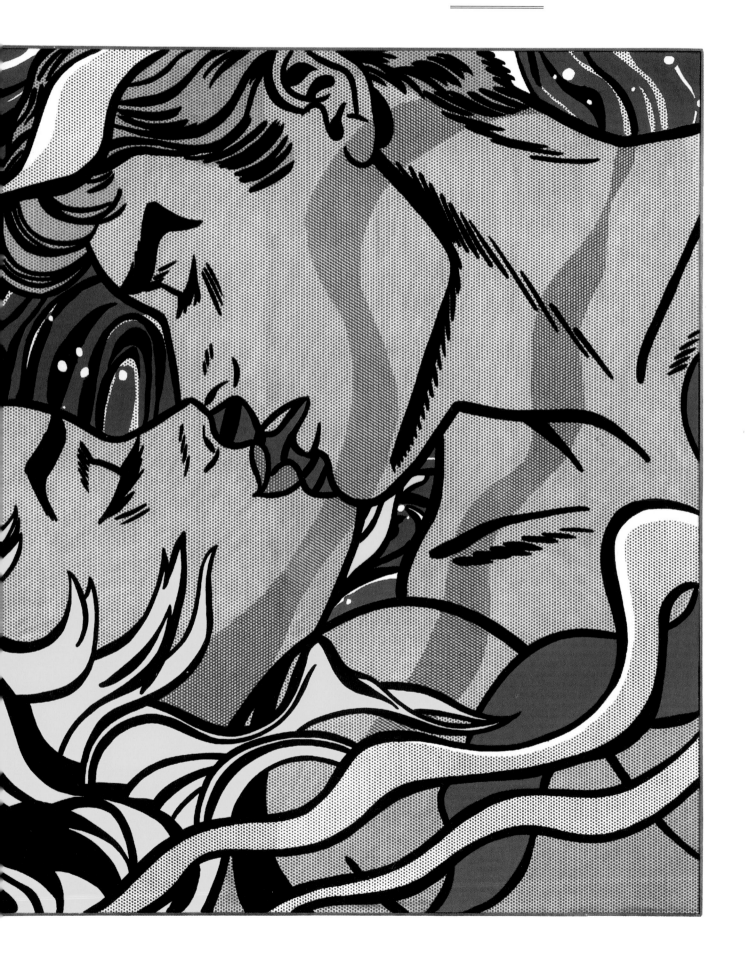

Meeting at Night

✎

The grey sea and the long black land;
And the yellow half-moon large and low;
And the startled little waves that leap
In fiery ringlets from their sleep,
As I gain the cove with pushing prow,
And quench its speed i' the slushy sand.

Then a mile of warm sea-scented beach;
Three fields to cross till a farm appears;
A tap at the pane, the quick sharp scratch
And blue spurt of a lighted match,
And a voice less loud, thro' its joys and fears,
Then the two hears beating each to each!

Robert Browning

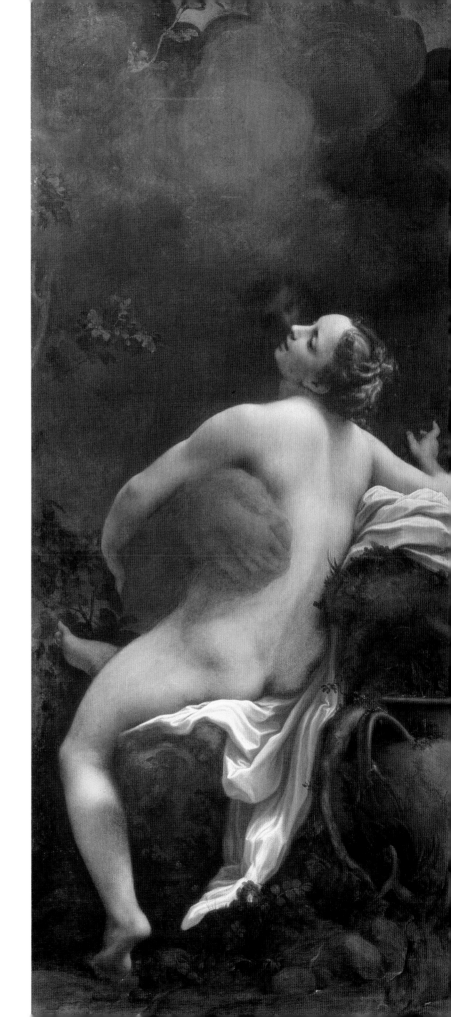

Correggio
Jupiter and Io
c. 1530, oil on canvas,
162 × 73,5 cm,
Kunsthistorisches Museum,
Vienna

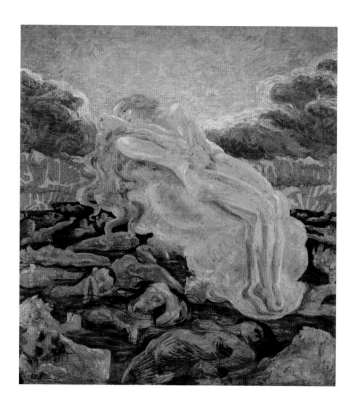

Umberto Boccioni
The Dream (Paolo and Francesca)
1908/09, oil on canvas,
140 × 130 cm,
private collection, Milan

Out of the Rolling Ocean, the Crowd

❧

Out of the rolling ocean, the crowd, came a drop gently to me,
Whispering, *I love you, before long I die,*
I have travel'd a long way merely to look on you to touch you,
For I could not die till I once look'd on you,
For I fear'd I might afterward lose you.

Now we have met, we have look'd, we are safe,
Return in peace to the ocean my love,
I too am part of that ocean, my love, we are not so much separated,
Behold the great rondure, the cohesion of all, how perfect!
But as for me, for you, the irresistible sea is to separate us,
As for an hour carrying us diverse, yet cannot carry us diverse forever;
Be not impatient – a little space – know you I salute the air, the ocean and the land,
Every day at sundown for your dear sake my love.

Walt Whitman

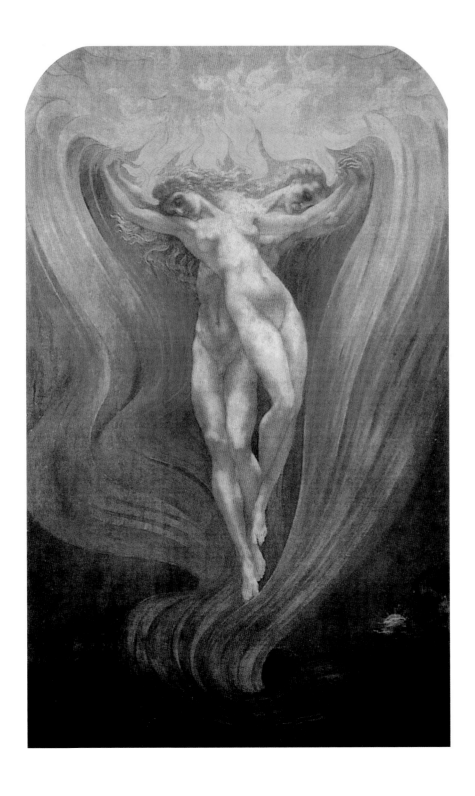

Jean Delville
L'Amour des Ames
no date, oil on canvas,
Musée d'Ixelles, Brussels

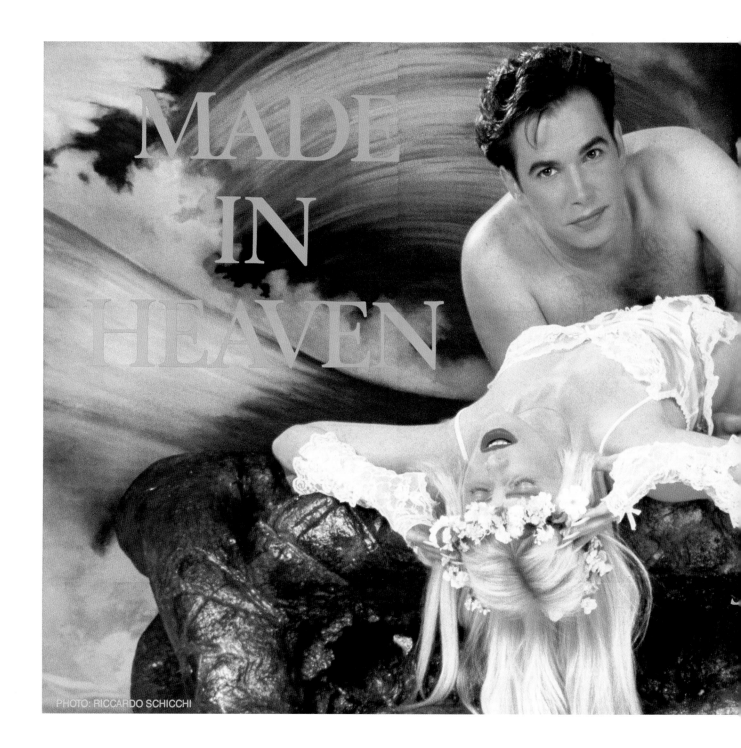

MADE IN HEAVEN

PHOTO: RICCARDO SCHICCHI

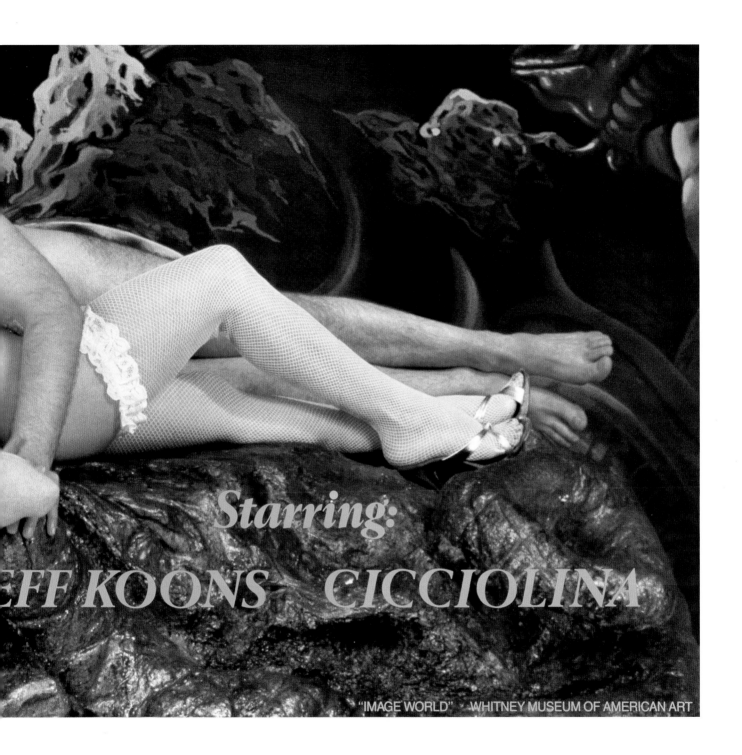

Jeff Koons
Made in Heaven
1989, lithograph on billboard,
317.5 × 690.9 cm
© Jeff Koons

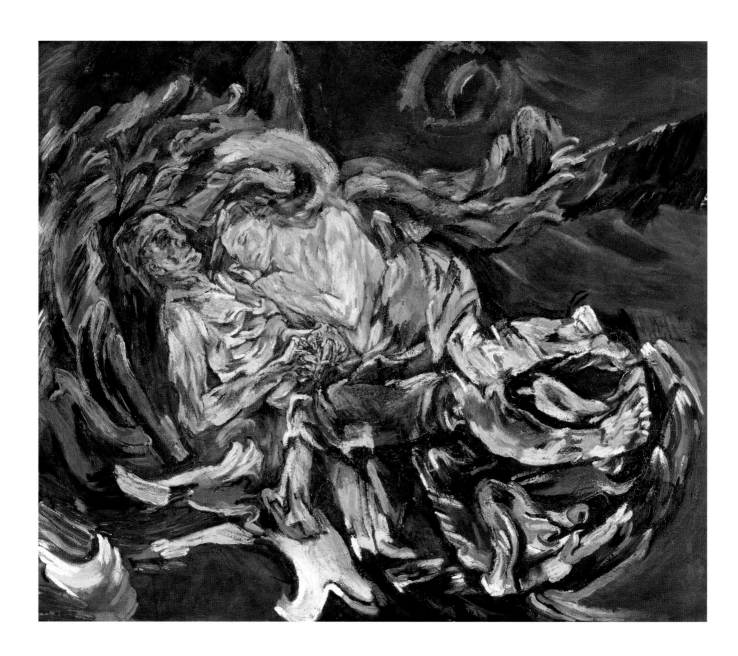

Oskar Kokoschka
The Bride of the Wind
1914, oil on canvas,
181 × 221 cm,
Kunstmuseum, Basel

Egon Schiele
The Embrace (Lovers II)
1917, oil on canvas,
100 × 170.2 cm,
Belvedere, Vienna

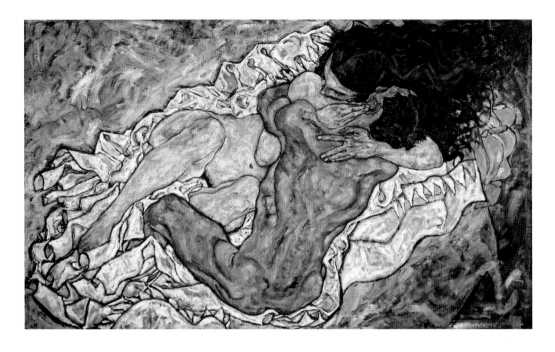

Love is a **passion** that
yields to nothing,
and to which everything
else submits.

—— Madeleine de Scudéry

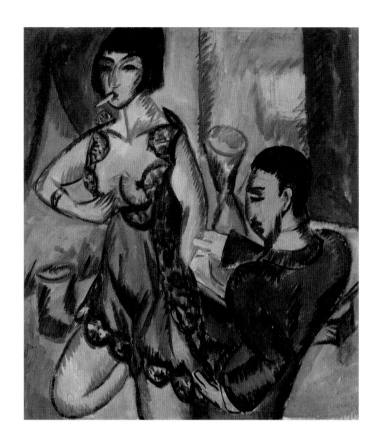

Ernst Ludwig Kirchner
Couple in a Room
1912, oil on canvas, 95 × 85 cm,
Berlin, private collection

I give you my love
and my body,
make me your **lover!**

—— Marie de France, **Bisclavret**

Otto Müller
Lovers
1919 / after 1925, distemper
on burlap, 106 × 80 cm,
Museum of Fine Arts, Leipzig

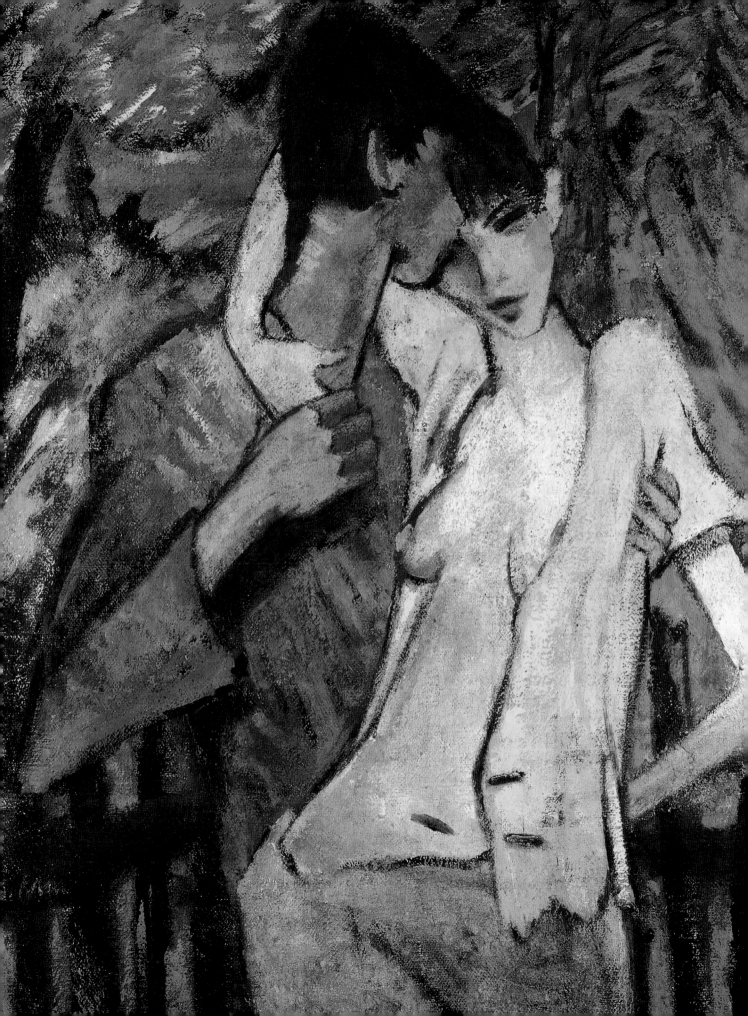

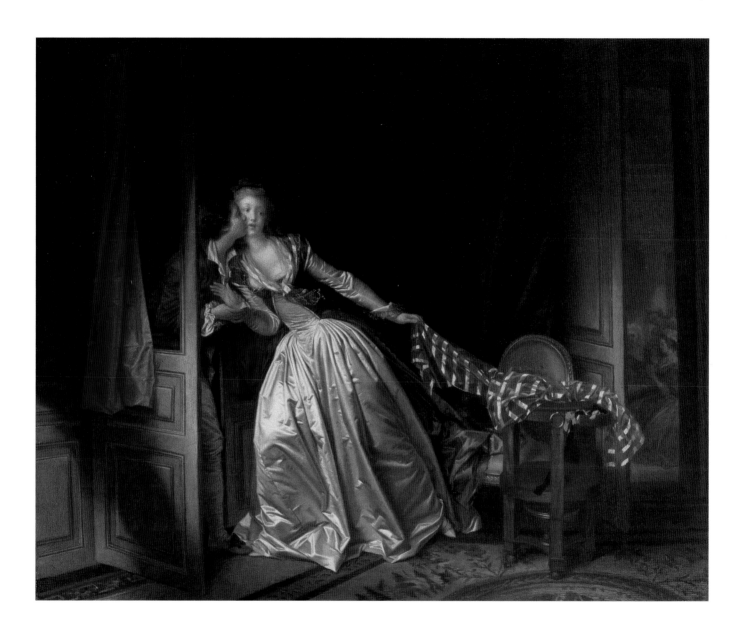

Jean-Honoré Fragonard
The Stolen Kiss
c.1788, oil on canvas,
45 × 55 cm, The Hermitage,
St Petersburg

since feeling is first

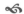

since feeling is first
who pays any attention
to the syntax of things
will never wholly kiss you;
wholly to be a fool
while Spring is in the world

my blood approves,
and kisses are a better fate
than wisdom
lady i swear by all flowers. Don't cry
– the best gesture of my brain is less than
your eyelids' flutter which says

we are for each other: then
laugh, leaning back in my arms
for life's not a paragraph

And death i think is no parenthesis

e.e. cummings

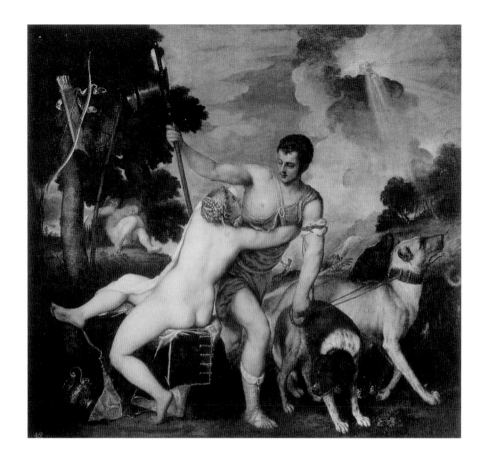

Titian
Venus and Adonis
c. 1555, oil on canvas,
177 × 187.5 cm, Museo Nacional
del Prado, Madrid

Unable are
the **Loved** to die,
For Love is
Immortality.

—— Emily Dickinson

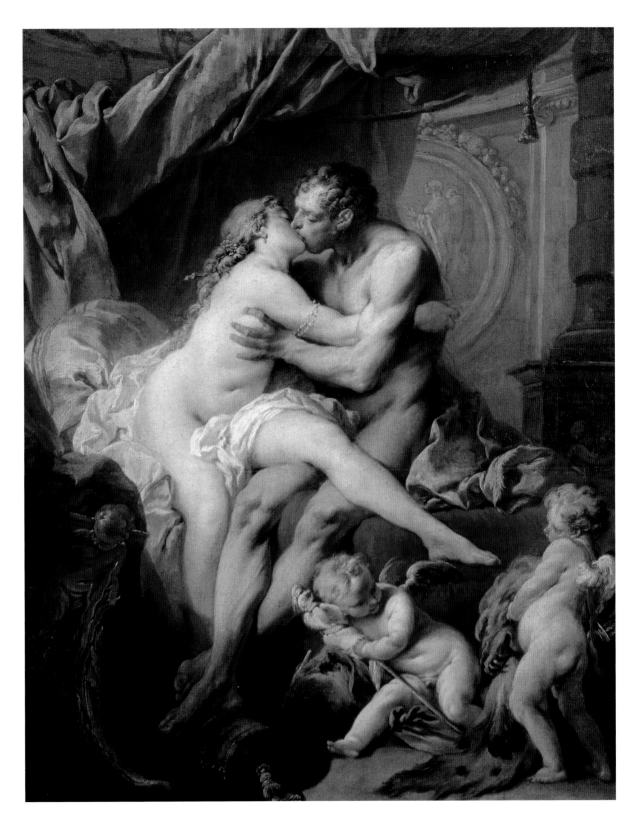

François Boucher
Hercules and Omphale
c. 1730, oil on canvas, 90 × 74 cm,
Pushkin Museum, Moscow

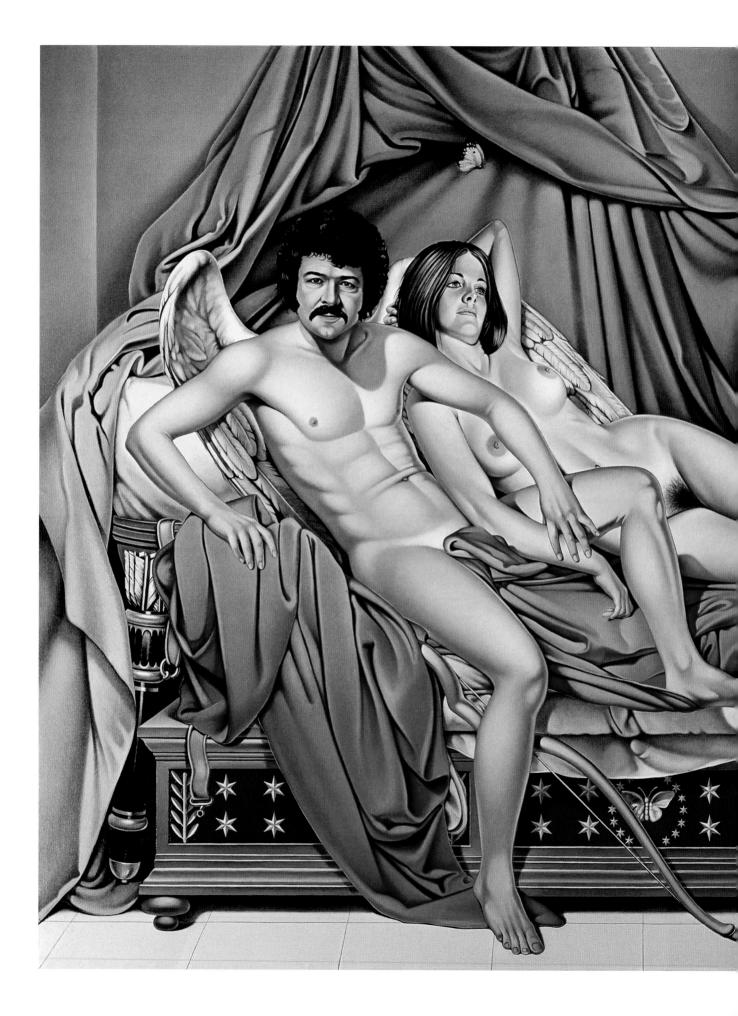

Mel Ramos
David's Duo (Cupid and Psyche)
1973, oil on canvas,
177.8 × 243.8 cm,
Crocker Art Museum,
Sacramento

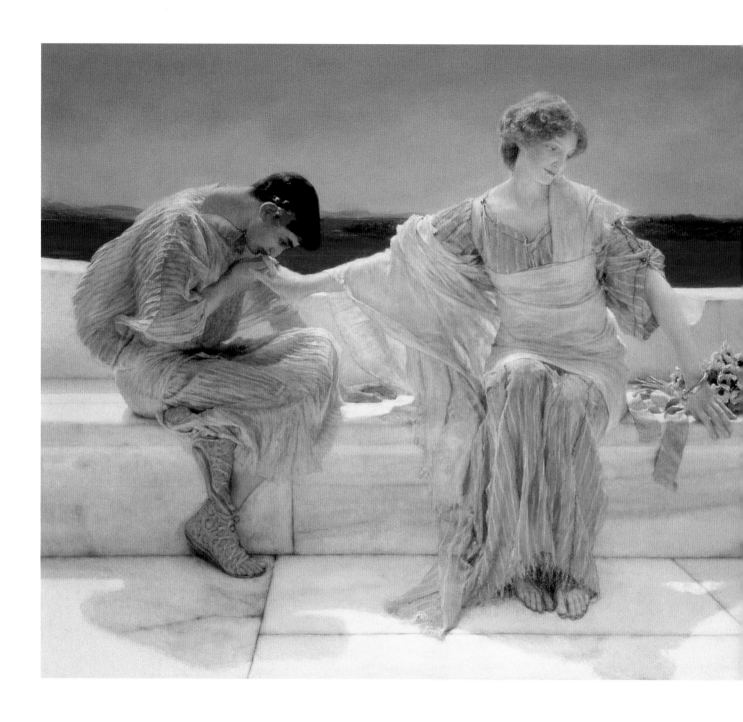

Sir Lawrence Alma-Tadema
Ask Me No More
1906, oil on canvas, 80.1 × 115.7 cm,
private collection

Love is Enough

❧

Love is enough: though the World be a-waning,
And the woods have no voice but the voice of complaining,
Though the sky be too dark for dim eyes to discover
The gold-cups and daisies fair blooming thereunder,
Though the hills be held shadows, and the sea a dark wonder,
And this day draw a veil over all deeds pass'd over,
Yet their hands shall not tremble, their feet shall not falter;
The void shall not weary, the fear shall not alter
These lips and these eyes of the loved and the lover.

William Morris

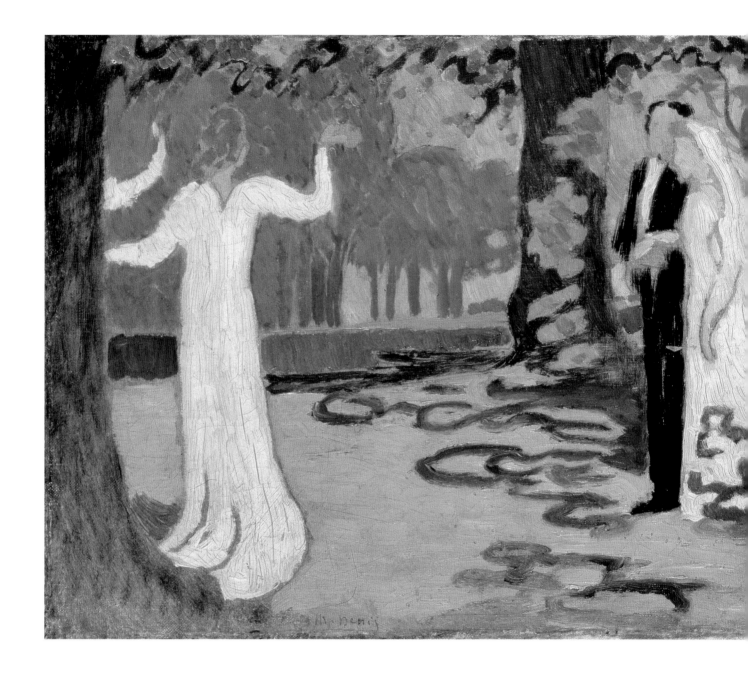

Whoso findeth a wife findeth a good thing.

—— Bible, **Proverbs 18:22**

Maurice Denis
Wedding Procession
1892/93, oil on canvas,
26 × 63 cm, The Hermitage,
St Petersburg

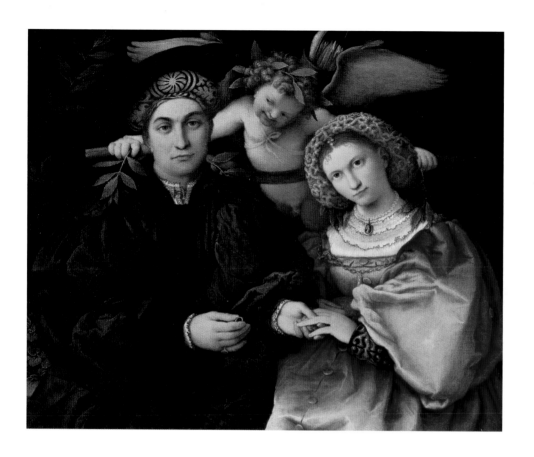

Lorenzo Lotto
**Marsilio Cassotti and
his Wife Faustina**
1523, oil on canvas, 71 × 84 cm,
Museo Nacional del Prado, Madrid

Jan van Eyck
The Arnolfini Marriage
1434, oil on wood, 81.8 × 59.7 cm,
National Gallery, London

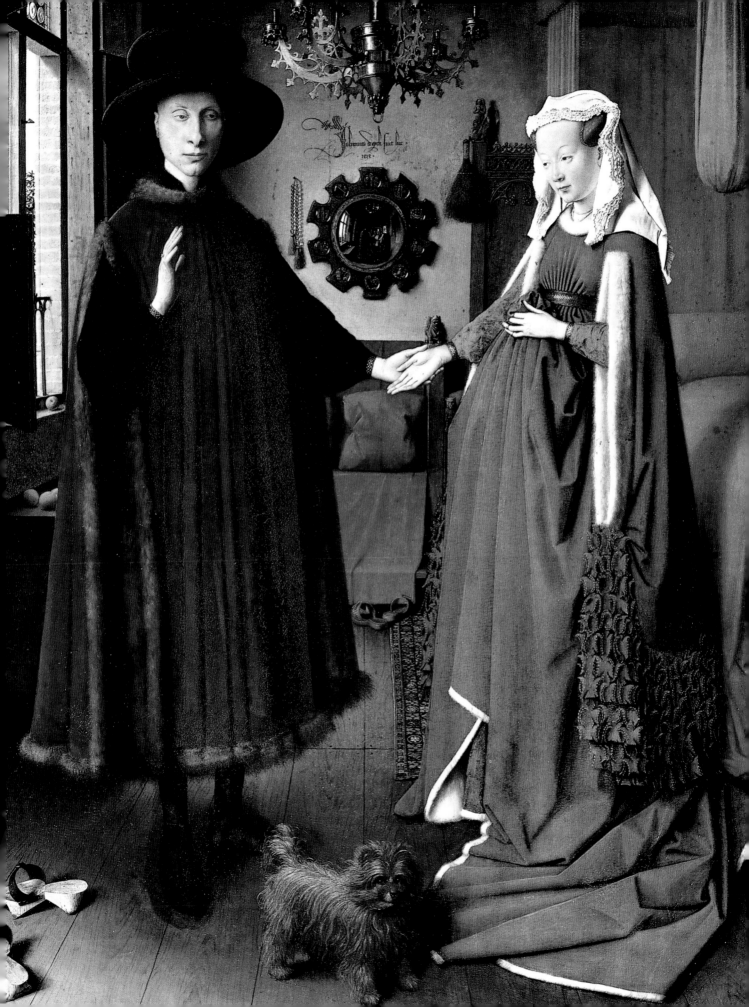

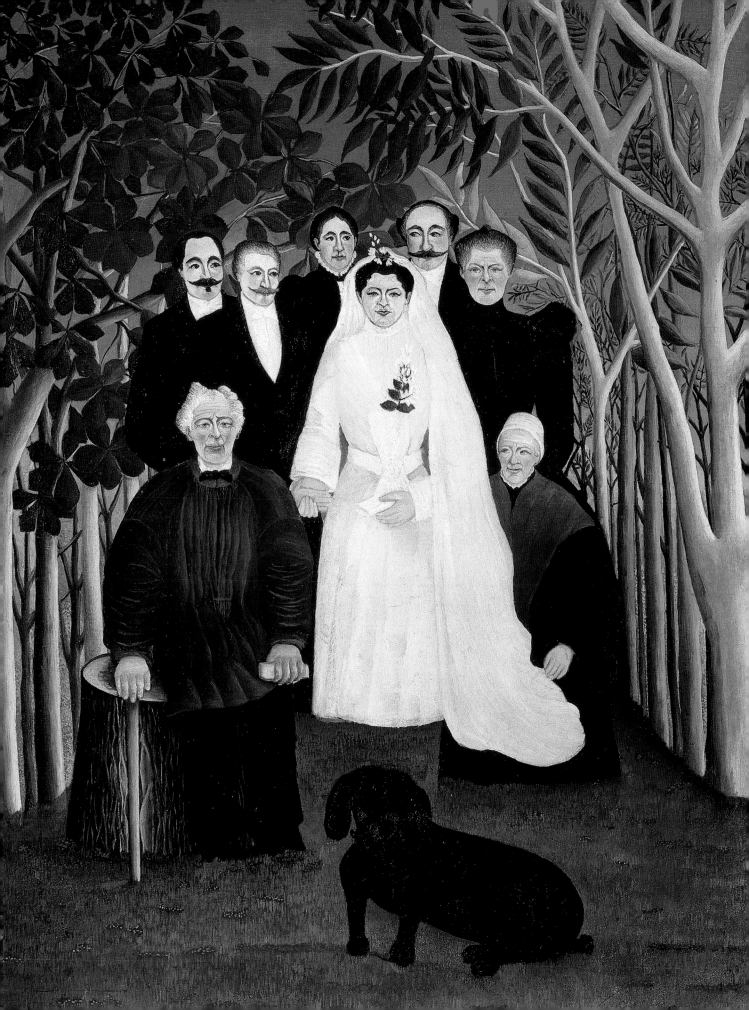

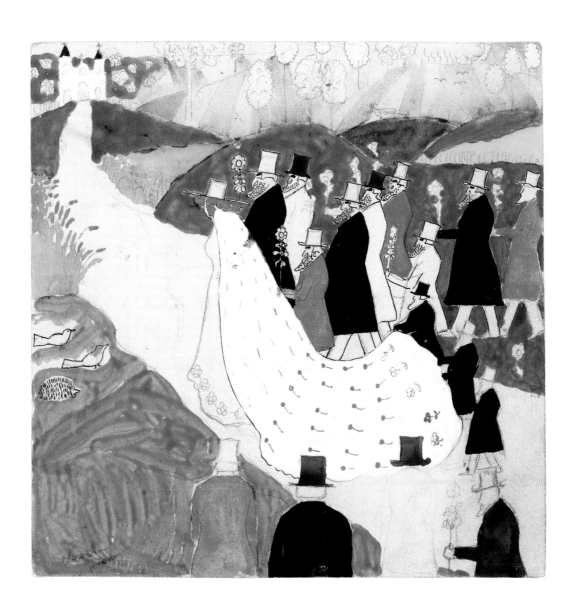

Henri Rousseau
The Wedding Party
1905, oil on canvas,
163 × 114 cm,
Musée de l'Orangerie, Paris

Kazimir Malevich
The Wedding
1907, watercolour, ink and pencil on paper
23 × 20 cm,
Museum Ludwig, Cologne

෧

If I speak in the tongues of men and of angels,
but have not love, I am a noisy gong or a clanging cymbal.

And if I have prophetic powers, and understand all mysteries
and all knowledge, and if I have all faith,
so as to remove mountains, but have not love, I am nothing.

If I give away all I have, and if I deliver up my body to be burned,
but have not love, I gain nothing.

Love is patient and kind; love does not envy or boast;
it is not arrogant or rude. It does not insist on its own way;
it is not irritable or resentful; it does not rejoice at wrongdoing,
but rejoices with the truth.

Love bears all things, believes all things, hopes all things,
endures all things.

St Paul, **1 Corinthians**

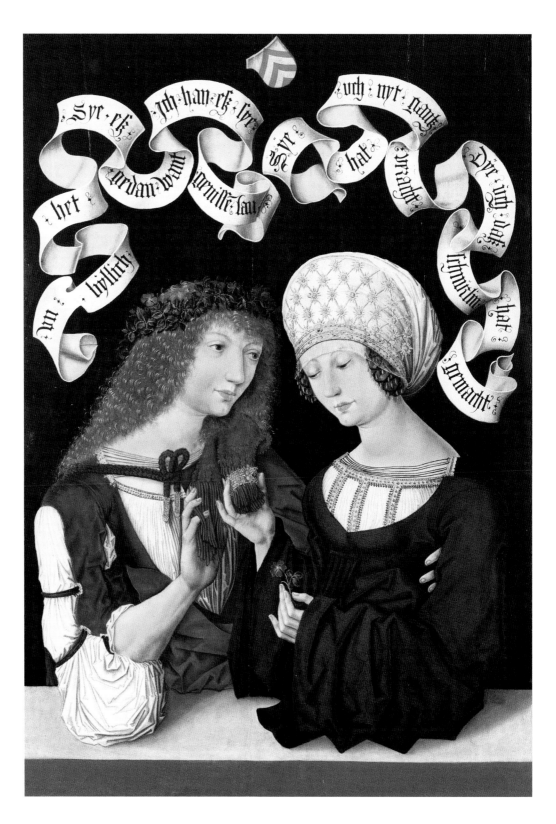

Master of the Housebook
The Pair of Lovers (Gotha)
c. 1480 – 1485, oil and tempera on wood,
118 × 82.5 cm,
Schlossmuseum, Gotha

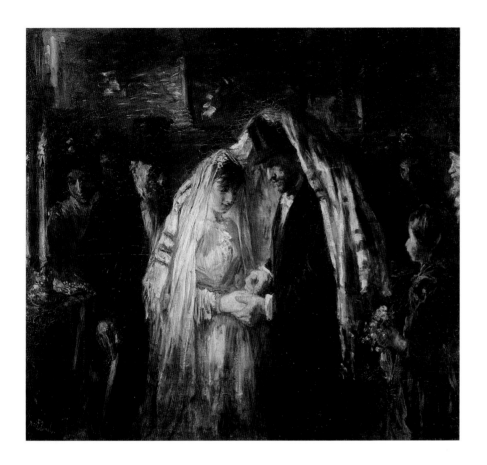

Jozef Israels
A Jewish Wedding
1903, oil on canvas, 137 × 148 cm,
Rijksmuseum, Amsterdam

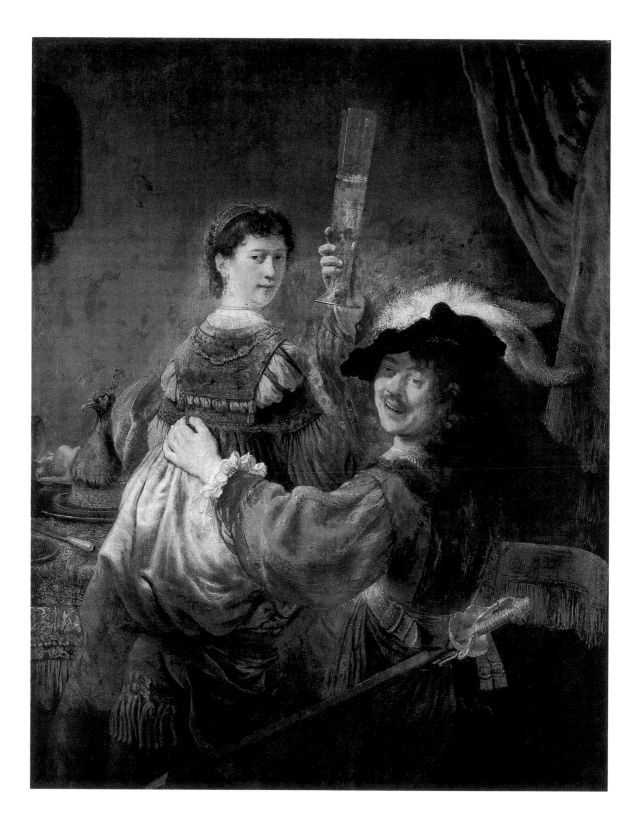

Rembrandt Harmensz. van Rijn
Self-Portrait with Saskia
c. 1635, oil on canvas,
161 × 131 cm, Gemäldegalerie
Alte Meister, Dresden

Love refines

The thoughts, and heart
enlarges; hath his seat
In reason, and is judicious;
is the scale
By which to heavenly love
thou mayest ascend.

—— John Milton, from **Paradise Lost**

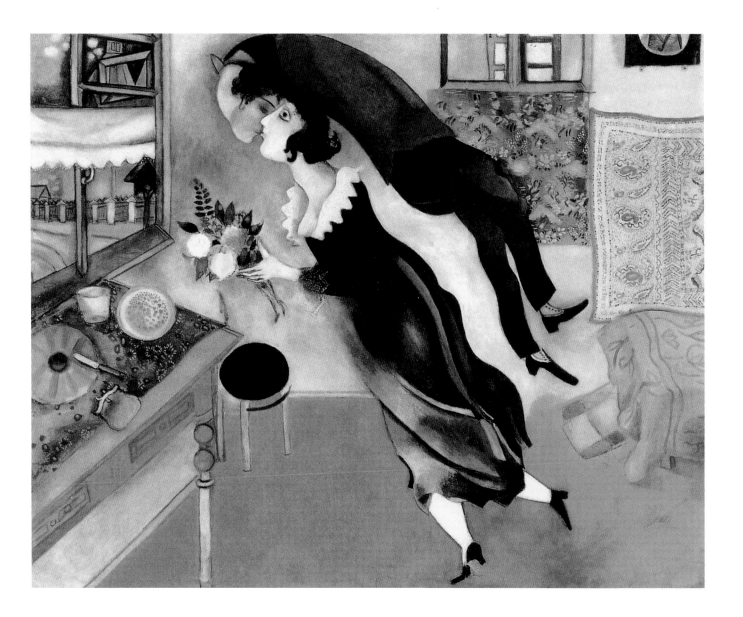

Marc Chagall
Birthday
1915, oil on cardboard, 80.6 × 99.7 cm,
Museum of Modern Art, New York

Give All to Love

❦

Give all to love;
Obey thy heart;
Friends, kindred, days,
Estate, good fame,
Plans, credit, and the Muse –
Nothing refuse.

'Tis a brave master;
Let it have scope;
Follow it utterly,
Hope beyond hope:
High and more high
It dives into noon,
With wing unspent,
Untold intent;
But it is a god,
Knows its own path,
And the outlets of the sky.

Ralph Waldo Emerson

Arnold Böcklin
The Honeymoon
c. 1876, oil on canvas,
72 × 52,5 cm,
Städel Museum, Frankfurt a. M.

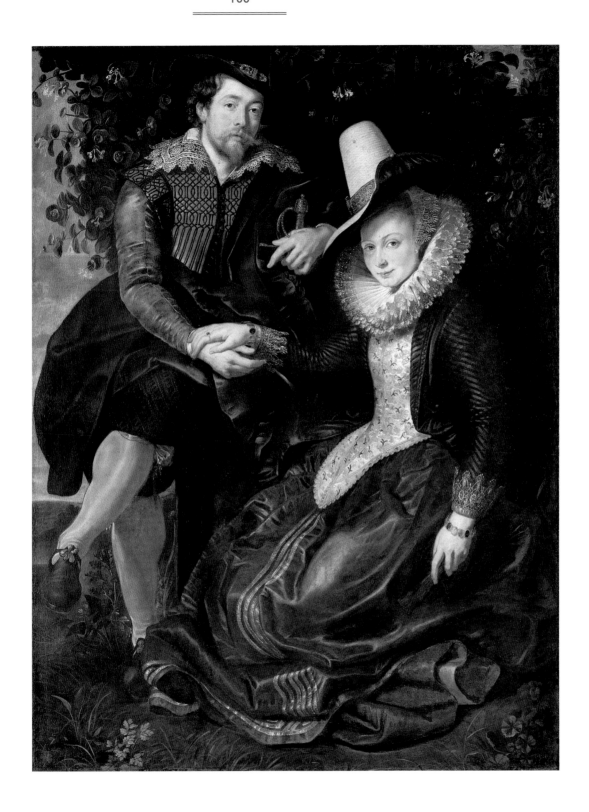

Peter Paul Rubens
**The Artist and his First Wife, Isabella Brant,
in the Honeysuckle Bower**
c. 1609, oil on canvas, 179 × 136 cm,
Alte Pinakothek, Munich

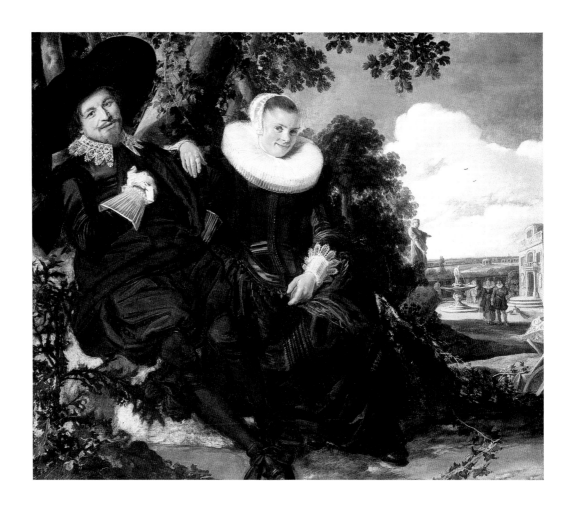

Franz Hals
**Marriage Portrait of Isaac Massa
and Beatrix van der Laen**
1625/26, oil on canvas, 140×166.5 cm,
Rijksmuseum, Amsterdam

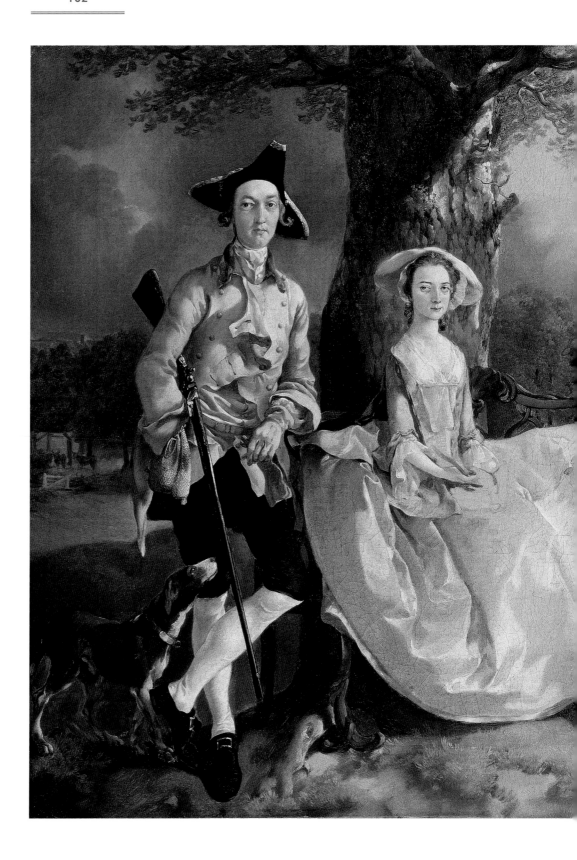

Thomas Gainsborough
Mr and Mrs Andrews
1748 / 49, oil on canvas, 70 × 119 cm,
National Gallery, London

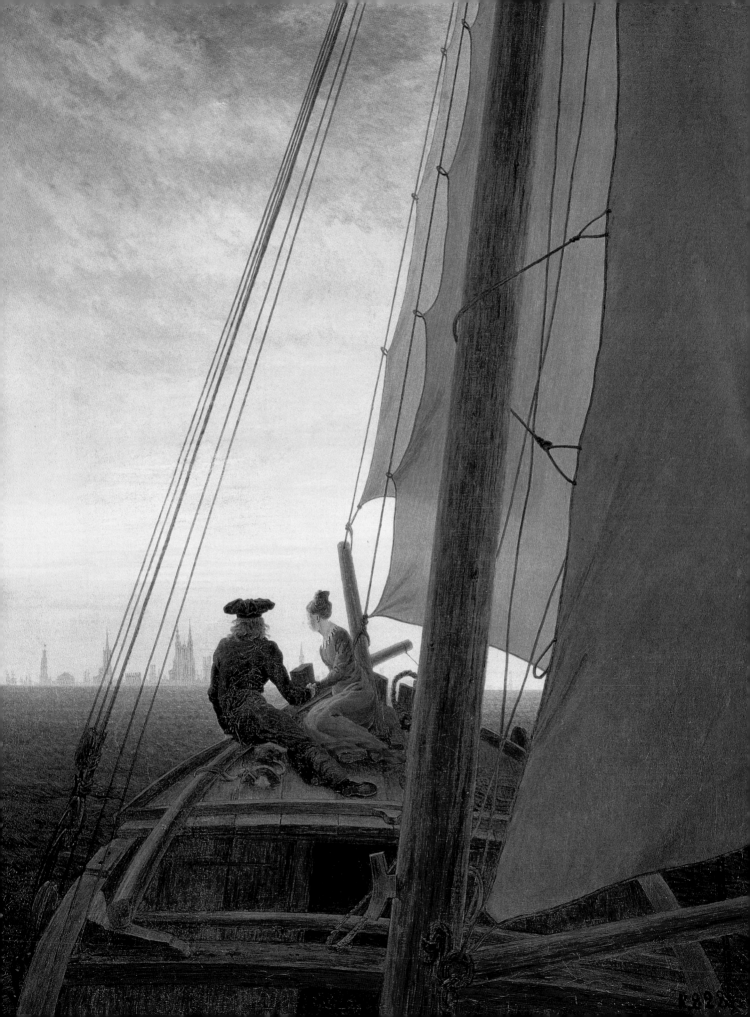

Sonnet CXVI

Let me not to the marriage of true minds
Admit impediments. Love is not love
Which alters when it alteration finds,
Or bends with the remover to remove:
O no! it is an ever-fixed mark
That looks on tempests and is never shaken;
It is the star to every wandering bark,
Whose worth's unknown, although his height be taken.
Love's not Time's fool, though rosy lips and cheeks
Within his bending sickle's compass come:
Love alters not with his brief hours and weeks,
But bears it out even to the edge of doom.
If this be error and upon me proved,
I never writ, nor no man ever loved.

William Shakespeare

Caspar David Friedrich
On a Sailing Ship
1818–1820, oil on canvas,
71 × 56 cm, The Hermitage,
St Petersburg

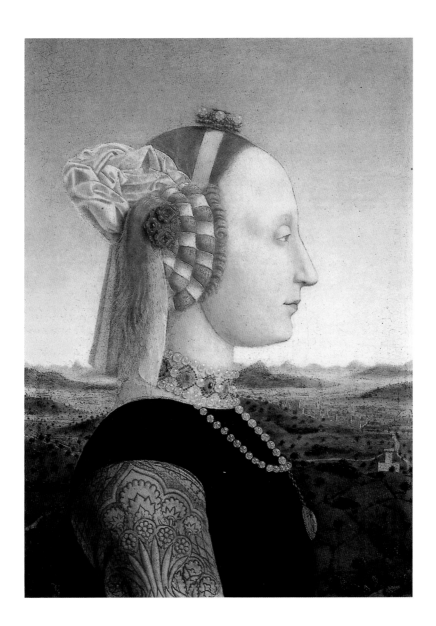

Piero della Francesca
**Portraits of the Duke and
Duchess of Urbino**
1465–1472, tempera on wood, 47 × 33 cm,
The Uffizi Gallery, Florence

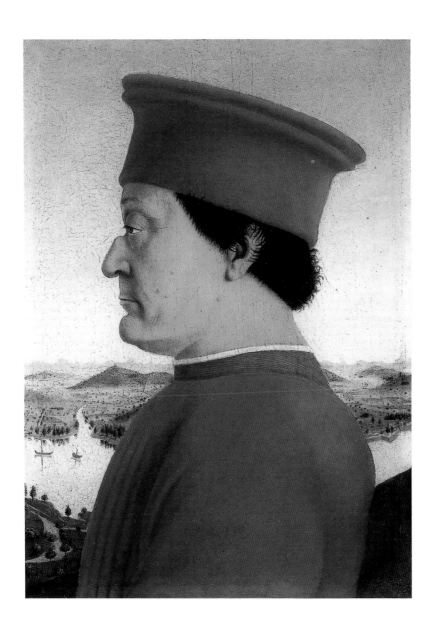

All time not spent in **love** is wasted.

—— Torquato Tasso

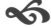

Alex Katz
Couple
1996, oil on canvas,
228.6 × 167.6 cm,
Museum Brandhorst,
Munich

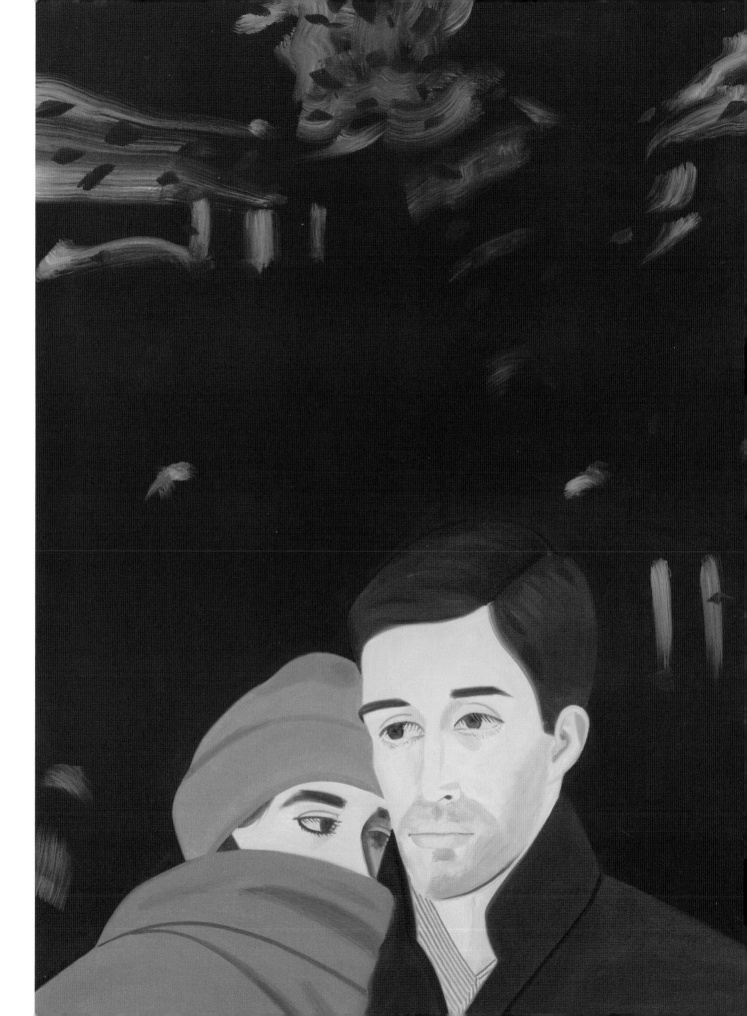

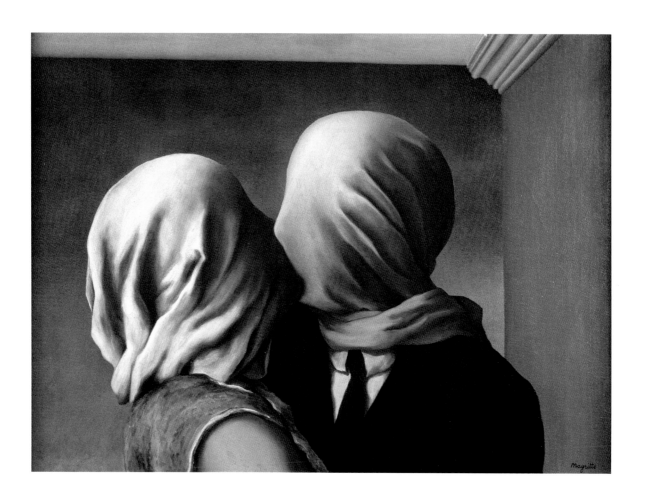

Maria Lassnig
Couple
2005, oil on canvas, 125 × 100 cm,
Courtesy the artist and
Hauser & Wirth

René Magritte
The Lovers
1928, oil on canvas,
54 × 73.4 cm,
Museum of Modern Art, New York

❧

Perfect she was, but as perfection is
Insipid in this naughty world of ours,
Where our first parents never learn'd to kiss
Till they were exiled from their earlier bowers,
Where all was peace, and innocence, and bliss
(I wonder how they got through the twelve hours),
Don Jose, like a lineal son of Eve,
Went plucking various fruit without her leave.

He was a mortal of the careless kind,
With no great love for learning, or the learn'd,
Who chose to go where'er he had a mind,
And never dream'd his lady was concern'd;
The world, as usual, wickedly inclined
To see a kingdom or a house o'erturn'd,
Whisper'd he had a mistress, some said two –
But for domestic quarrels one will do.
…
Don Jose and the Donna Inez led
For some time an unhappy sort of life,
Wishing each other, not divorced, but dead;
They lived respectably as man and wife,
Their conduct was exceedingly well-bred,
And gave no outward signs of inward strife,
Until at length the smother'd fire broke out,
And put the business past all kind of doubt.

George Gordon, Lord Byron,
from **Don Juan**

Lucian Freud
And the Bridegroom
1993, oil on canvas,
231.8 × 196.2 cm,
Lewis Collection

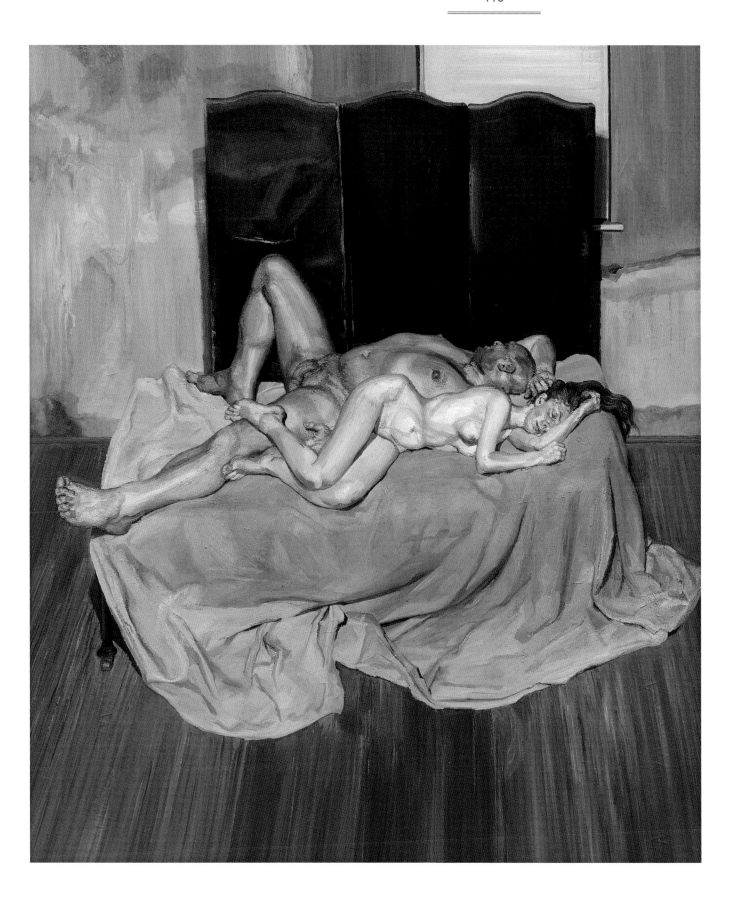

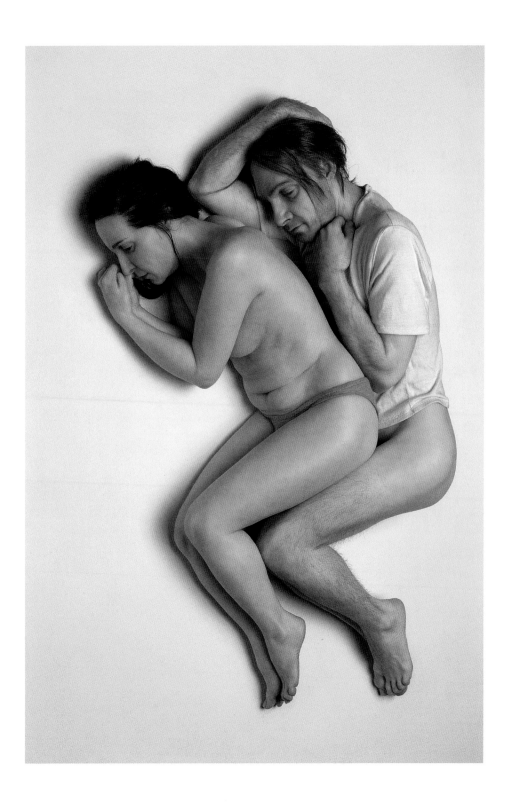

Ron Mueck
Spooning Couple
2005, mixed media,
116.5 × 104 × 79 cm,
Tate / National Galleries
of Scotland

The Grave of Love

I dug, beneath the cypress shade,
What well might seem an elfin's grave;
And every pledge in earth I laid,
That erst thy false affection gave.

I press'd them down the sod beneath;
I placed one mossy stone above;
And twined the rose's fading wreath
Around the sepulchre of love.

Frail as thy love, the flowers were dead
Ere yet the evening sun was set:
But years shall see the cypress spread,
Immutable as my regret.

Thomas Love Peacock

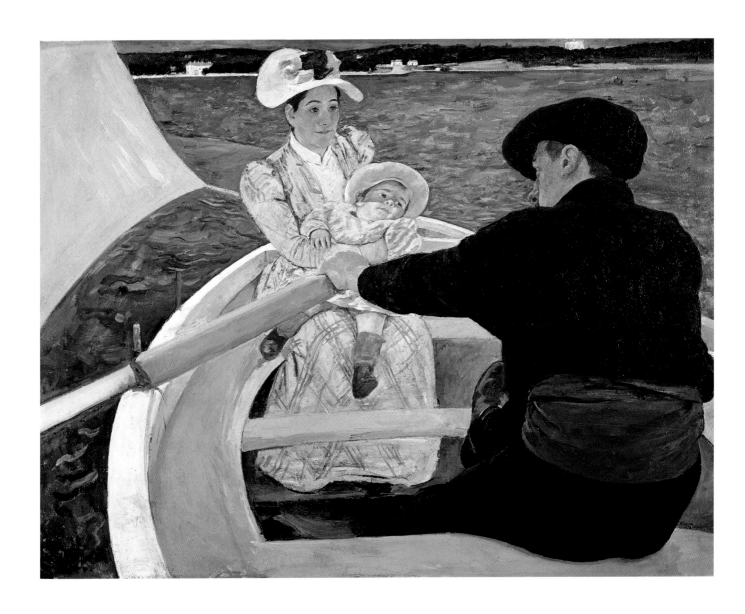

Mary Cassatt
The Boating Party
c. 1893 / 94, oil on canvas,
90 × 117 cm,
National Gallery of Art,
Washington, DC

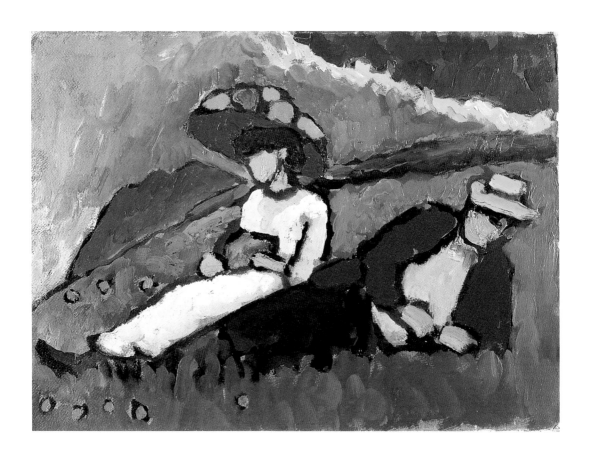

Gabriele Münter
Jawlensky and Werefkin
1909, oil on cardboard, 32.7 × 44.5 cm,
Städtische Galerie
im Lenbachhaus, Munich

Life has taught us that love consists not of gazing at each other, but of looking out **together** in the same direction.

—— Antoine de Saint-Exupéry, from **Airman's Odyssey**

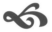

Frida Kahlo
Frida Kahlo and Diego Rivera
1931, oil on canvas,
100 × 79 cm, San Francisco
Museum of Modern Art,
San Francisco

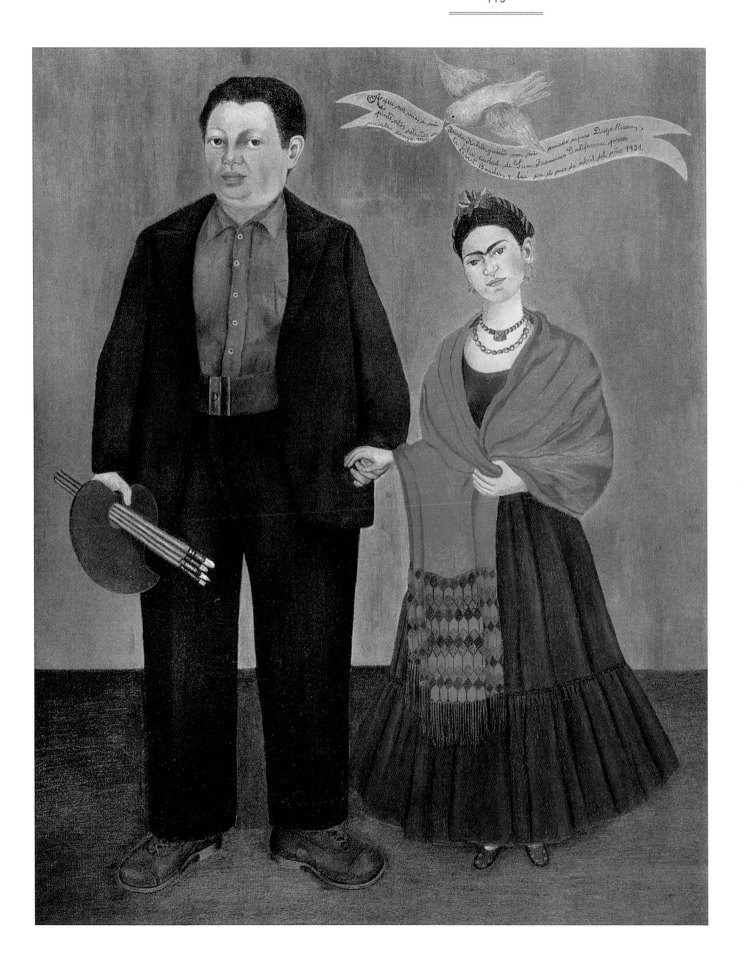

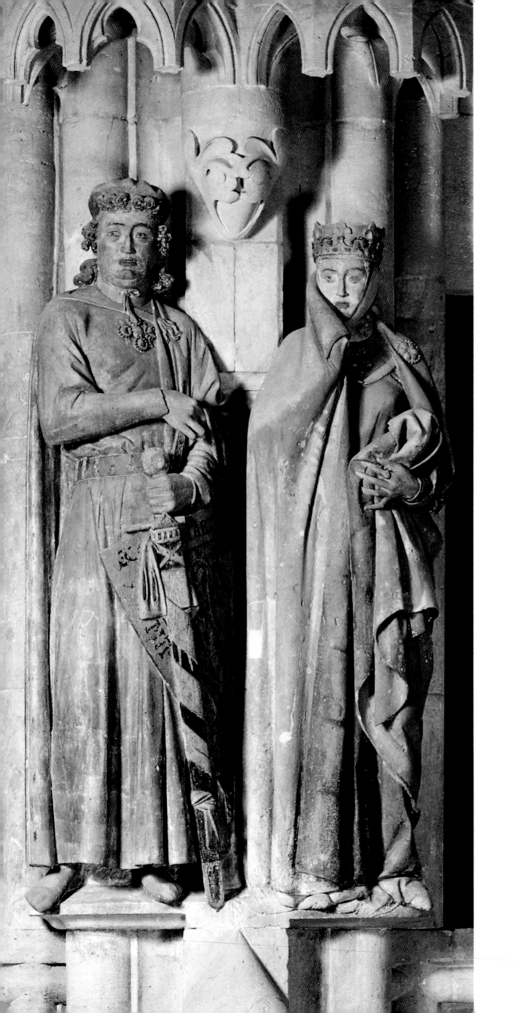

Naumburg Master
Doner Portraits of Ekkehard and Uta
c. 1260, sandstone,
Cathedral of St Peter and St Paul,
Naumburg

Naumburg Master
**Doner Portraits of Hermann
and Reglindis**
c. 1260, sandstone,
Cathedral of St Peter and St Paul,
Naumburg

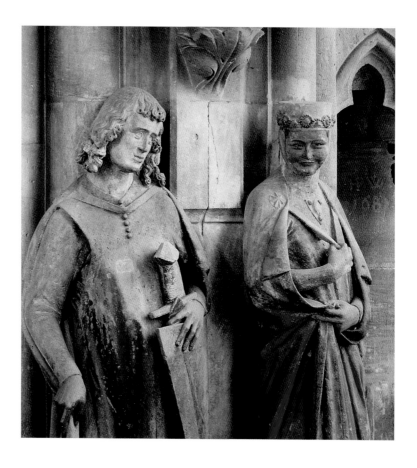

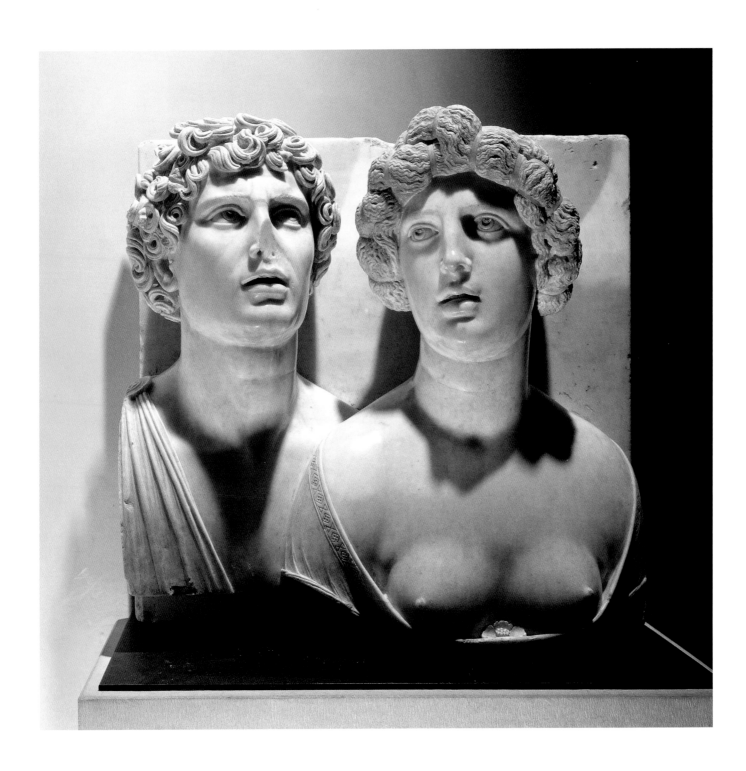

Tullio Lombardo
Double Portrait of a Young Couple
1500, Carrara marble,
47 × 50 cm, Venice,
Ca' d'Oro, Galleria Franchetti

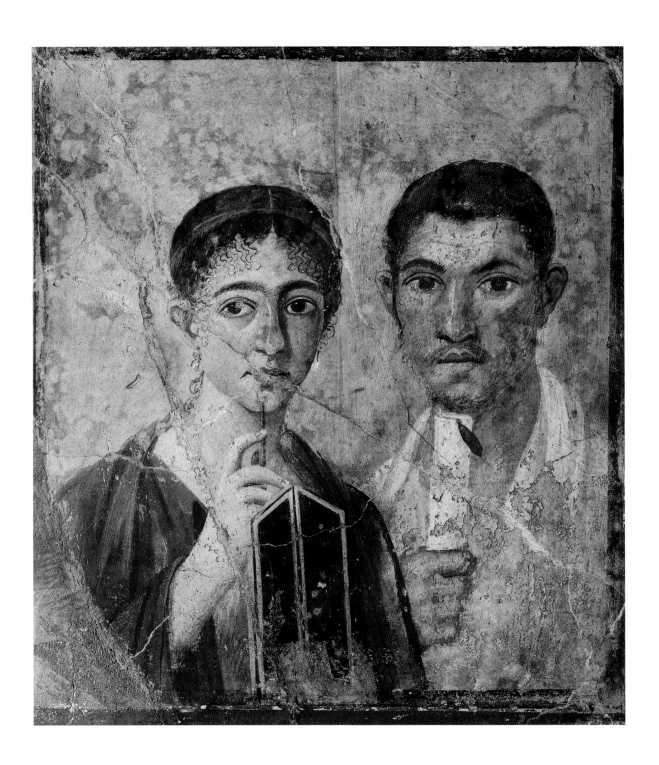

Anonymous, Roman
A Baker with his Wife
1st century AD, mural from Pompeii,
48.9 × 41 cm,
Naples, Museo Archeologico
Nazionale

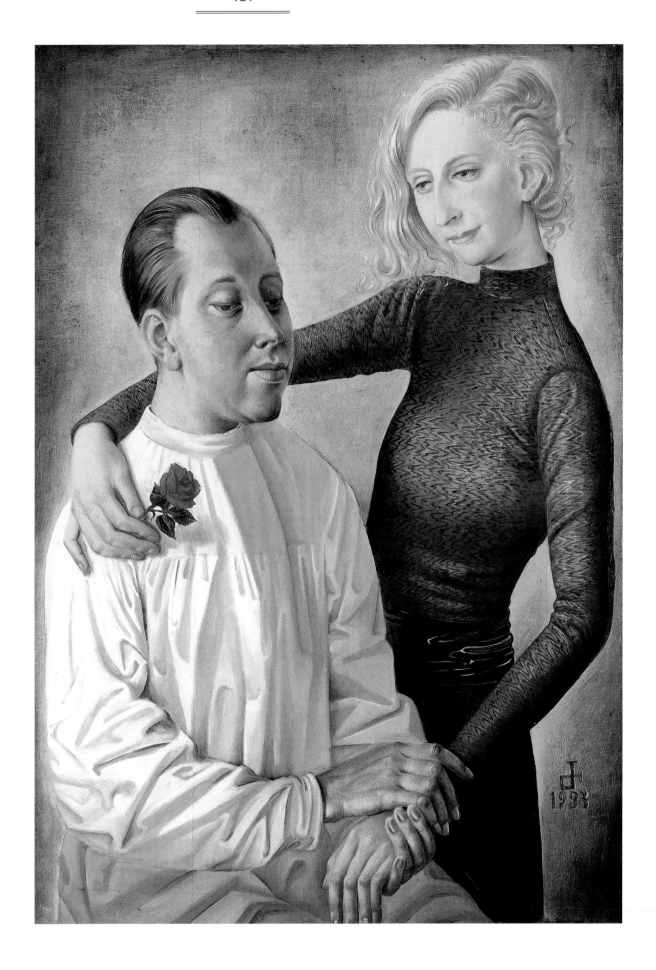

That is the peculiarity of **love,** that it can never stay the same; it must grow continuously if it is not to diminish.

—— André Gide,
from **The Counterfeiters**

Otto Dix
**Portrait of the Painter
Hans Theo Richter
and his Wife Gisela**
1933, mixed media on canvas,
100 × 70 cm,
Otto-Dix-Haus, Gera

Darby and Joan

Hand in hand when our life was May
Hand in hand when our hair is grey
Shadow and sun for every one,
As the years roll on;
Hand in hand when the long night tide
Gently covers us side by side –
Ah! lad, though we know not when,
Love will be with us forever then:
Always the same, Darby my own,
Always the same to your old wife Joan.

Frederic Edward Weatherby

Vincent van Gogh
Two Lovers, Arles
1888, oil on canvas, 32.5 × 23 cm,
private collection

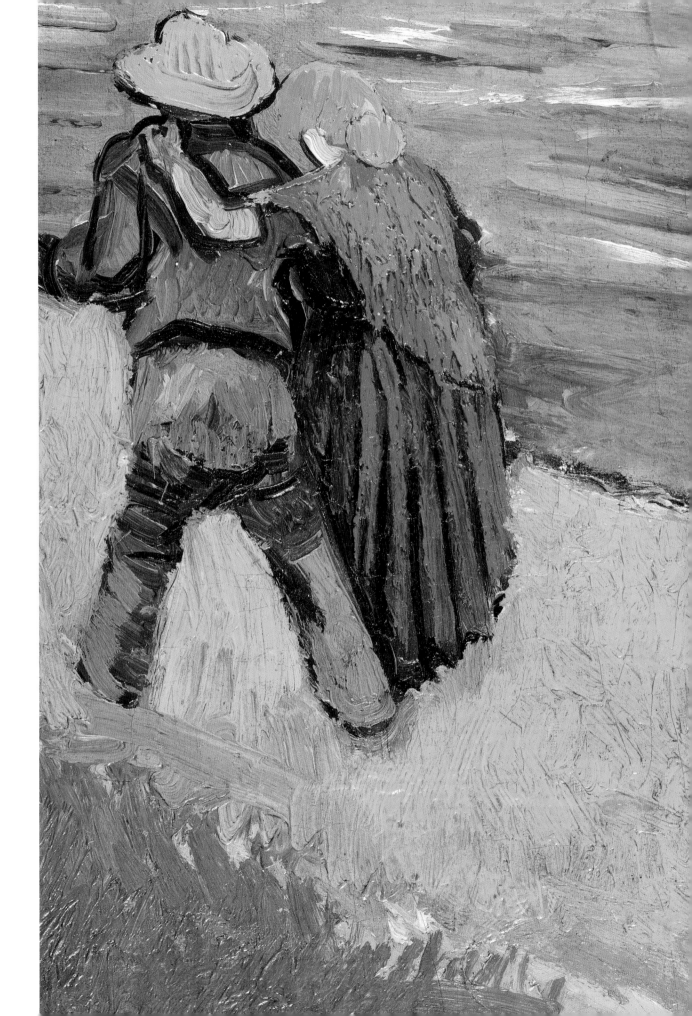

Photo Credits

The illustrations in this publication have been kindly provided by the museums, institutions, and archives mentioned in the captions, or taken from the Publisher's archives, with the exception of the following:

© Archive Ida Chagall, Paris **40, 97**

Artothek **18/19, 26, 78, 86/87; 38** (Bayer & Mitko); **100** (Blauel/Gnamm); **27, 28** (Christie's Images Ltd.); **39, 127** (Bridgman); **43, 60, 90** (Peter Willi); **69** (Photobusiness); **99** (Städel Museum); **116** (Joseph S. Martin)

Bildarchiv Foto Marburg **93**

Bridgeman Art Library **34, 56, 57, 84, 111**

Courtesy the artist and neugerriemschneider, Berlin **50**

Fotostudio Otto, Vienna **44**

Getty Images **61; 31** (De Agostini); **53** (Time Life Pictures), **122** (De Agostini)

Bruno Jarret, Paris **47**

Klut, Dresden **95**

© Lucian Freud Archive **113**

Mel & Leta Ramos Family Collection **82/83**

Munch Museet, Oslo **65**

© Museo Nacional del Prado, Madrid **58**

Museum Brandhorst/Photo: Haydar Koyupinar **109**

Museum der bildenden Künste, Leipzig, Gerstenberger 1995 **77**

© National Gallery, London **89, 102/103**

Rheinisches Bildarchiv, Cologne **91**

Réunion des Musées Nationaux (RMN) **42**

Stedelijk Museum, Amsterdam **94**

ARTIST ROOMS Acquired jointly with the National Galleries of Scotland through The d'Offay Donation with assistance from the National Heritage Memorial Fund and the Art Fund 2008 **114**

© San Francisco Museum of Modern Art, San Francisco **119**

Imprint

© Prestel Verlag, Munich · London · New York, 2013
© for the works reproduced is held by the artists, their heirs or assigns, with the exception of Marc Chagall, Camille Claudel, Jean Victor Delville, Maurice Denis, Otto Dix, Wassily Kandinsky, Alex Katz, Tamara de Lempicka, Roy Lichtenstein, René Magritte, Gabriele Münter, Mel Ramos with © VG Bild-Kunst, Bonn 2012; Frida Kahlo with © Banco de México Diego Rivera Frida Kahlo Museums Trust/VG Bild-Kunst, Bonn 2012; Oskar Kokoschka with © Fondation Oskar Kokoschka/VG Bild-Kunst, Bonn 2012; Edvard Munch with © The Munch Museum/The Munch Ellingsen Group/VG Bild-Kunst, Bonn 2012; Pablo Picasso with © Succession Picasso/VG Bild-Kunst, Bonn 2012; Lucian Freud with © Lucian Freud Archive; Jeff Koons with © Jeff Koons; Maria Lassnig with © Maria Lassnig; Pierre et Gilles with © Pierre et Gilles; Jack Vettriano with © Jack Vettriano 1992

Front cover: Jack Vettriano, The Singing Butler (detail), 1992, **36/37**
Frontispiece: Vasily Kandinsky, Riding Couple, 1906/07, oil on canvas, 55 × 50.5 cm, Munich, Städtische Galerie im Lenbachhaus

Prestel Verlag, Munich
A member of Verlagsgruppe Random House GmbH

Prestel Publishing Ltd.
4 Bloomsbury Place
London WC1A 2QA
Tel. +44 (0)20 7323-5004
Fax +44 (0)20 7636-8004

Prestel Publishing
900 Broadway, Suite 603
New York, NY 10003
Tel. +1 (212) 995-2720
Fax +1 (212) 995-2733
www.prestel.com

Prestel Verlag
Neumarkter Straße 28
81673 Munich
Tel. +49 (0)89 4136-0
Fax +49 (0)89 4136-2335
www.prestel.de

Library of Congress Control Number is available; British Library Cataloguing-in-Publication Data: a catalogue record for this book is available from the British Library; Deutsche Nationalbibliothek holds a record of this publication in the Deutsche Nationalbibliografie; detailed bibliographical data can be found under: http://dnb.d-nb.de

Prestel books are available worldwide. Please contact your nearest bookseller or one of the above addresses for information concerning your local distributor.

Translated from the German by: Jane Michael, Munich
Editorial direction: Claudia Stäuble and Franziska Stegmann
Copyedited by: Chris Murray
Picture editor: Franziska Stegmann
Design and Layout: Sehsam.de, Leipzig
Production: René Fink
Art direction: Cilly Klotz
Origination: Repro Ludwig, Zell am See
Printing and binding: TBB, a.s., Banská Bystrica, Slovakia

MIX
From responsible sources
FSC® C022120

Verlagsgruppe Random House FSC®-DEU-0100
The FSC®-certified paper Galaxi Keramik was supplied by Papier-Union, Ehingen.

ISBN 978-3-7913-4818-6